"Of all designed objects, letters are probably the most pervasive, very familiar yet amazingly diverse in their appearance… there seems to be no limit to human ingenuity when it comes to varying letterforms."

— Gerard Unger, typographer

Published by
Princeton Architectural Press
202 Warren Street
Hudson, New York 12534
www.papress.com

24 23 22 21 4 3 2 1 First edition

ISBN 978-1-64896-047-5
Library of Congress Control Number: 2021930823

Editors: Jennifer Thompson and Sara Stemen
Designer: Kelcey Gray

Primary typeface: Escalator, designed by
Jesse Ragan and Ben Kiel of XYZ Type.
XYZtype.com

About the typeface, from XYZ Type: "Among abundant
geometric sans serifs, Escalator claims its own tiny territory
that is both fresh and historically authentic. Based on late
1950s American architectural signage, it was originally
commissioned for the code-compliant restoration of a
landmark New York City skyscraper."

Additional typefaces: Lifted Sans and Lifted Serif,
designed by Regan Fred Johnson.

Experiment, Practice,
and Explore

Let's
Make
Letters!

Lettering for Beginners
and Beyond

Kelcey Gray

Princeton Architectural Press · New York

We all make letters.

Aside from speech, it's one of the most immediate ways we communicate. Each of us has our own unique handwriting that identifies us. We absorb and observe typography daily—from emails to advertisements to produce stickers at the grocery store. Letters are everywhere.

Capturing ideas in words that we see daily is, as typographer Gerard Unger says, the "domain of authors," and "to turn their work into typography, to make it accessible and attractive, is the domain of typographers and graphic designers." And, I would add, the domain of letterers.

If you've ever been curious about the art and practice of lettering but find yourself completely overwhelmed by the idea of making p-e-r-f-e-c-t letters, this book will take the pressure off. Within these pages, you'll find exercises that are more experimental than instructional and more attainable than purely inspirational.

My hope is that you will use the exercises within this book as thought starters—as a provocation to make more work, more experiments, and more ideas. Maybe you want to get better at drawing. Maybe you want to learn more about lettering basics. Maybe you want to do something offscreen. You may draw some ugly letters! You may make some weird letters! You may end up liking those ugly or weird letters. They're unique. Never let the fear of not doing it right get in the way of doing it at all.

So, this book is for you: you, the lettering enthusiast, the teacher, the idle doodler, the high school student, the graphic designer, the person with unintelligible handwriting, the social worker, the visual artist.

Put your fears behind you and put pen—or pencil, or brush, or marker—to paper.

How to Use This Book

A Thought Starter

Each of the exercises in this book could lead you to developing your own project. Consider how these exercises might add to your current creations.

A Workbook

Make a mess! With the power of tracing paper, you can work within or on top of pages in this book.

A Teaching Tool

Attention, teachers of the world! Consider giving your students a few of these exercises to get their gears turning. Adapt and respond as you see fit!

A Boredom Fighter

When you're caught between tasks or simply don't know what to do with yourself, remember to pick this book up. If you've got pencil and paper, you can do it!

Above all, approach each exercise with an open mind and a positive outlook. Don't be afraid to challenge conventions and explore the far reaches of legibility.

Let's C what you make!

the alphabet

acronyms

things your mom says

a quote by someone you admire

your favorite hobby

names of countries

not sure wh

an inside joke

types of food

a group or organization you belong to

animal names

your initials

your grocery list

"thank you"

your favorite dessert

band names

opposites

supercalifragilisticexpialidocious

your pet's name

idioms

action verbs

the city of your birth

the street you grew up on

at to letter?

book titles

99¢

your favorite hobby

travel destinations

interjections

the word *lettering*

your team mascot

ambigrams

Never lettered?
New to lettering?
Ever wondered what
that little space
in the middle of an
O is called? The
next few pages will
walk you through
some foundational
typographic
know-how.

1

basics

What Is Lettering?

Lettering is the creation of built-up letterforms. Built up of what, you ask? That's entirely up to you.

Typographer Gerrit Noordzij is famous for saying that the basic, most "fundamental" built-up form in lettering is the stroke. Strokes may be careful and tidy or expressive and messy. That stroke can be made with a pen, a marker, a pencil, pieces of tape, hairs, or fruit rinds. Any of these tools, when combined and ordered in particular ways, can be used to create letters.

Lettering is a vast and varied practice with a myriad of applications. Letterers, typographers, and graphic artists have created letters by hand for thousands of years for commercial, cultural, and personal purposes. Historian Johanna Drucker says that these "visual forms of the letters of the alphabet provide a rich record of cultural history and ideas which interweave the domains of philosophy and religion, mysticism and magic, linguistics and humanistic inquiry." Letters can communicate our

values and emotions. Lettering applied to a surface can lay claim to a possession ("Hey! That's my notebook!"). Lettering can function as a sign for a storefront. It can decorate the label of a product or enliven the side of a building. Lettering communicates.

By Pen Stroke or by Pixel
When we talk about lettering throughout history, we're primarily referring to lettering made by hand. Three thousand years ago, humans hand-carved letters into stone. The ancient Egyptians painted their language onto papyrus. They carved letters into ceramic vases. Medieval scribes used ink and quill to create 2-inch-thick tomes. From stones to brushes to quills to graphite pencils to ballpoint pens—only in the past few decades did lettering flourish with digital tools. Whether you're familiar with digital tools or not, the intent of this book is to instill in you a love of analog letters, built up by various strokes or materials. Made by hand. Made by *your* hand.

"Lettering is the art of drawing letters; calligraphy is the art of writing letters; typography is the art of using letters."

Ian Barnard, lettering artist and calligrapher

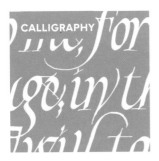

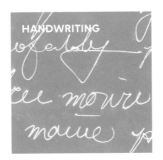

Calligraphy

An age-old practice, calligraphy can be considered a form of both lettering and handwriting. Calligrapher Katharine Scarfe Beckett succinctly describes calligraphy as "writing as art."

Calligraphy is single-stroke lettering, typically created with a broad-nibbed, flat-tipped pen or brush.

Calligraphy is an ever-evolving practice that has developed over thousands of years, across countless cultures. Different visual styles are representative of varied and changing tools—from quills and parchment or vellum made from animal skin, used by thirteenth-century monks, to current-day writing tools.

The goal of calligraphy is to compose rhythmic and harmonious arrangements of letters into refined compositions.

Handwriting

Whether you write in cursive or in print, polished or messy, handwriting is uniquely connected to a person's identity, unique to you.

Handwriting is fast, efficient, and transactional. For thousands of years, humans have used written communication to share stories, conduct business deals and trades, approve official documents, and record official creeds—think the Declaration of Independence.

Speaking of the Declaration, did you know that January 23 is National Handwriting Day? It's the birthday of Declaration signatory John Hancock, whose energetic signature has become one of the most famous in history.

"Type is a beautiful group of letters, not a group of beautiful letters."

Matthew Carter, typographer

Typefaces and Fonts

Typefaces are sets of ready-made shapes enabling the reproduction of similar, identical-looking letters (e.g., all lowercase n's look the same). Initially carved out of wood and cast in metal and later created out of plastics and ink transfers, typefaces are now distributed digitally.

Who makes typefaces? These patient folks are called typographers. Typographers spend hours, even years, developing a full typeface. Who knows how much time went into designing each letter of each keystroke?

Curious about the difference between a typeface and a font? A typeface is a particular design of type (think Helvetica), while a font is a set of characters in a particular size and weight (think Helvetica Italic). Think of the difference between a typeface and a font as the difference between an album and its songs.

Top Tools of the Trade

Tracing paper

Aka trace or parchment, is a thin, translucent sheet of paper that enables architects, engineers, typographers, designers, and artists to create and copy drawings. This humble sheet of paper is a powerful iterative tool—you can draw, trace, rotate, reflect, and redraw your ideas without the need of a light box, scanning tools, or software.

Pens

It's likely that you'll be using pens for the majority of your lettering on these pages and beyond. Their semipermanence requires a good deal of guts and can-do attitude to make marks—and mistakes—on the page.

Pencils

Pencils are perfect for your initial sketches and ideas. Once you've got a sketch you love, you can ink over your drawing with the pen of your choice. From the hardest to softest of leads, all are welcome here.

Brushes

Whether you're using a brush pen or a traditional paintbrush, brushes are a great tool for creating contrast, energy, and emotion in your lettering. Try experimenting with different brush shapes, inks and paints, and brush techniques.

The appearance of spray-painted lettering can change based on the distance the can is held from the page. Can you think of other tools where distance—or time—changes the appearance?

Spray paint

Fancy a fast medium? Spray paint has been a go-to for graffiti artists for decades. It's richly saturated, accessible, and can be applied to almost any surface.

Stencils and straightedges

Use these as handy side-kicks to your drawing tools. Stencils such as french curves and architecture stencils can give you a good set of shapes to kick-start your lettering. A straightedge is a great sketching tool that can be used for establishing your baseline, x-height, and cap height—we'll get to that later. For a boost of confidence, use straight-edges and stencils.

Markers

Bold! Brave! Confident! As with most of the tools on this page, markers come in endless shapes, sizes, and colors. Markers have the added benefit of being highly pigmented and saturated with ink. Use them to make gestural marks, fill in forms, and add dimension to your work.

Tools and Tone

Modern philosopher, communication theorist, and media mastermind Marshall McLuhan once said that "the medium is the message." In his book *Understanding Media: The Extensions of Man* (1964), he describes in great detail how the way in which we communicate is just as important—if not more important—than what we say.

In the words of designer and beloved Stanford University educator Matt Kahn, "it is the treatment of the subject at least as much as the subject itself that does the talking."

Simply put, the tool you use to create can greatly affect the mood of your letters. Just like the different volumes, pitches, languages, dialects, and cadences with which we speak, so, too, can different lettering tools affect the way the visual word communicates.

Denotation and Connotation

If you lettered the word *bubbly* in simple, unadorned capital letters, it would be simply that. A typographic depiction of the word *bubbly*. That's denotation, the literal text that's displayed on the page. However, if you were to letter the same word in inflated, jumbled up, bursting pink letters, that word would seem to adopt a whole new meaning. Not only does the word communicate "bubbly," it also looks "bubbly." The style in which a word is lettered can reinforce—or contradict—the connotation of the word.

Sometimes the most joyful and surprising letterforms can be made with the most unconventional stuff.

Unconventional Materials and Misuse

Items like tape, foodstuff from your fridge, discarded plastic, or ceramic tiles can add meaning and context to your work.

If you can't seem to find any of these items, try using a conventional item, like a pencil, in an unconventional way. How about holding it between your toes?

Many of the exercises in this book suggest using pen or pencil on paper—don't let that stop you!

Try re-creating any of the exercises with untraditional drawing tools.

For some healthy variation, go to page 87, "Same Letter, Different Tool"…

Start by Scribbling

First things first. Find a spot to sit. Get comfortable. Grab a sheet of paper and a mark-making tool of your choice. Take a deep breath.

This is where you relax and loosen up your muscles, including your creative ones. You wouldn't expect a runner to launch into a 5k without warming up, so don't expect great results from yourself if you jump in cold. Allow yourself time to get a feel for the pen, the paper, your state of mind.

The following pages will catch you up on some handwriting history and teach you some schools of preparatory exercises. Try your hand at a few and see which work best for your creative style and spark inspiration.

The Palmer Method
Defined by its iconic slant and uniform strokes, this handwriting method is a "series of self-teaching sessions in rapid, plain…muscular movement writing…for the home learners." Ever an idealist, the method's founder, Austin Palmer, encouraged perfection through repetition "where an easy and legible handwriting is the object sought." The Palmer Method was introduced in the public schools of the mid-1880s, and it was widely publicized to both young people and adults.

If you ever had to write the same sentence a hundred times on a chalkboard as punishment, you've experienced (arguably) a punitive misuse of the Palmer Method.

Spencerian Script
In use from the late 1800s to the early 1900s, Spencerian script dominated the handwriting scene. Eponymously named for its founder, Platt Rogers Spencer, Spencerian script was ovoid and highly flourished—what we might consider fancy by today's standards of writing. Palmer, a contemporary of Spencer, deemed the script to be far too feminine and championed a more stripped-down and efficient approach to writing.

The Zaner-Bloser Method
If you learned cursive in school, you likely learned the Zaner-Bloser Method. Founded by master penman Charles Paxton Zaner, this method became popular around the same time as Palmer penmanship.

You've probably seen Spencerian script without even knowing it! The iconic Coca-Cola logo is a classic example of Spencerian.

$\mathcal{M} \quad \mathcal{M} \quad \mathcal{M} \quad \mathcal{M}$

1 2 3 4

1 The Palmer Method, 2 Spencerian Script,
3 The Zaner-Bloser Method, 4 The D'Nealian Method

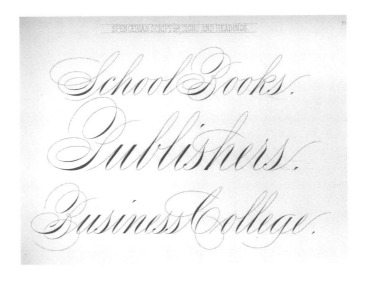

↑
*New Spencerian
Compendium*,
P. R. Spencer's Sons, 1887

Zaner, like Palmer, primarily concerned himself with the idea of "muscular movement," or repetition, creating muscle memory to perfect each form. Proper posture, paper placement, and elbow movement were critical to creating pleasing letters.

Tracing the ideal letter shapes on elementary school worksheets is how many of us first encountered the Zaner-Bloser Method.

The D'Nealian Method
Popularized in the 1970s, the D'Nealian Method was taught by Donald Neal Thurber. Thurber found the Zaner-Bloser Method to be too complex for children learning cursive. By reducing the complexity (i.e., loops and flourishes) of the letters, Thurber made it more accessible and easier to teach to children who were still developing more nuanced motor skills. In addition to cursive, a print, or "block letter," alphabet was added to the D'Nealian repertoire—maintaining an italic slant like the cursive's.

While these four schools of practice emphasize perfection, you may find that idealized letter shapes are extraordinarily difficult to create freehand. You may also find that you prefer a little bit of personality or imperfection in your work. That's OK! That's what makes each piece unique. Use these methods to earn an appreciation for how things "should" be done, then learn how to break the rules like a designer. Remember: practice makes practiced.

But this isn't a book about handwriting, so why are we talking about handwriting history?

These four schools of handwriting share a common mechanical process with lettering—moving the hand, the arm, and the body to make letters—and it all starts with scribbling.

Let's take a look behind the beauty. These masters of the pen didn't get good overnight—no, they practiced and warmed up, too! Even though they may seem aimless, these simple, repetitive squiggles and curlicues help to train the brain and the hand— preparing them for the lettering to come.

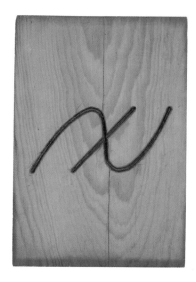

←
This 5-by-7-inch board has recessed channels carved into it in the shape of a cursive *x*, à la Palmer. These practice blocks acted as templates so that students could practice the motor skills to master the lowercase letters.

Start with big motions and gestures, then work your way down to smaller, more controlled movements.

LESSONS 52 AND 53

Not forgetting or neglecting the two-space compact oval drill with which each lesson should start, the p well be spent in study and practice of the letters on page 52.

LESSON 54—Drill 61

This copy furnishes all the movement drill necessary in beginning this lesson. Count ten for each drill the reverse traced oval. About sixteen complete drills should be made to the minute. This drill is especiall the development of a light, quick movement difficult.

Drill 62

Study the curve of the first stroke; study the loop at the top, and give especial attention to the fact that half the entire length of the letter. With an easy, light movement make from forty-five to fifty letters to the mi

Drill 63

The angular finishing stroke shown in drill sixty-three is very popular with many excellent teachers of bu number of letters should be made in a minute as in drill sixty-two. Its practical feature is the direction take may be joined to any letter following. Count 1, 2, swing; or 1, 2, 3, for each letter.

LESSON 55—Drill 64

Write a page of this copy; more if you have sufficient time. A continuous steady movement should be the beginning to the ending of the word.

↑
The Palmer Method of Business Writing
A. N. Palmer, 1935

Not just for cursive letters!

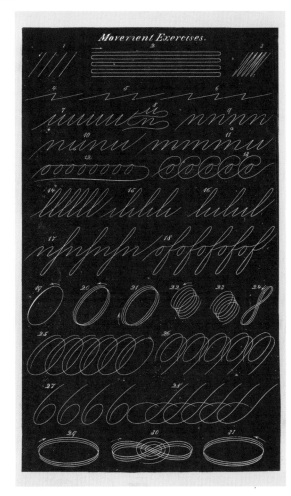

↑
*Spencerian Key to
Practical Penmanship*
Henry Caleb Spencer,
1866

Warming Up

The penmanship examples at left involve strict lessons with perfection in mind. The goal of this book isn't to achieve perfection but to instill a curiosity about letterforms and encourage practice. Use the following techniques to loosen up and prepare yourself for your lettering practice.

Waves
Start with swift upward and downward motion. Over time, try to regulate the height and width of each wave.

Loops
Swing your marker round and round! Start with messy loops and then shoot for more uniformity.

Lines
It takes all kinds! Vertical, horizontal, diagonal, wiggly; here again, aim for regularity and repetition.

Nonsense
Let it all out. Sometimes the strangest of shapes can yield the most surprising letters. Is that an *M*?

Repetition
Create a stroke and then retrace that stroke repeatedly. It's good for the muscle memory.

cap height
The height of
a capital letter.

x-height
The height of a
lowercase letter.

baseline
The line upon which
letters sit.

↑
Three photographs of a
schoolboy preparing his
desk posture for writing.
From *The Art of Business
Writing*.

Three Lines

Acting as a scaffold for letterforms, these three lines—the cap height, x-height, and baseline—will guide you as you create letterforms.

Letterers and typographers use these lines to ensure that each letter has a uniform height and proportion. Typically, these lines are drawn horizontally to reflect the reading order of Western languages. But this isn't true for all languages!

Other languages make use of their own lettering guides. In Chinese and Japanese lettering and handwriting, boxes and vertical lines are used to denote the equal sizing and spacing of each character.

The same three lines serve as wild and expressive guidelines for curvy letters, jagged letters, hairy letters, slender letters, and anything in between. You can use these three lines for any of the exercises in this book.

↑
James Edmondson

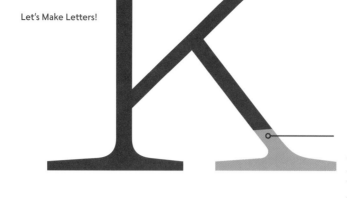

serif

A (usually) small protrusion at the end of a letterform. Typefaces that make use of these are called serif typefaces.

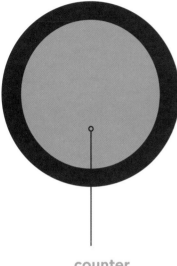

counter

A contained area of negative space within a letterform: think o, d, and p.

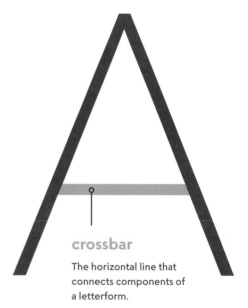

crossbar

The horizontal line that connects components of a letterform.

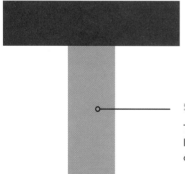

stem

The primary part of the letterform that's vertical or diagonal.

finial

The curved or tapered end of a stroke.

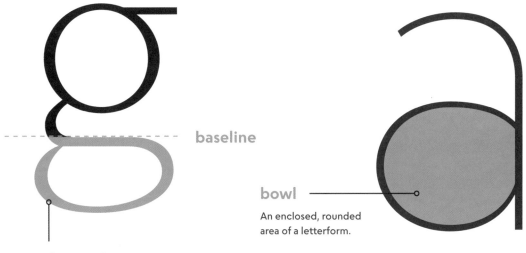

baseline

bowl

An enclosed, rounded area of a letterform.

descender

A part of a letterform that extends below the baseline.

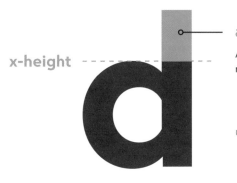

ascender

A part of a letterform that rises above the x-height.

x-height

Typographic Anatomy

terminal

The end of a stroke of a letterform. Terminals can take different shapes. In this case, it's called a "ball terminal."

There are thousands of different ways our alphabet can take shape. And though each font, each alphabet—and each letter—may be distinct, they all share the same basic essential, repeatable forms. In other words, what makes written language—language! Here are a few terms and characteristics that Latin letterforms share.

Optics and Overshoot

Overshoot is a term used to describe the degree to which rounded and pointed letters extend above and below the bounds of a flat character. The capital letter *O* and similar characters are going to be a wee bit taller than the capital letter *T*.

Why? It's optics. Plainly put, what our eyes see and our brain perceives. The three lines— baseline, x-height, and cap height—on which we base our lettering are merely guides and not meant to be mathematically exact. Even though it seems practical and tidy to have every letter be the exact same height, our eyes tend to disagree.

Take, for example, the sets of shapes at right. Imagine that the triangle is an *A*, the square an *H*, and the circle an *O*. Squint at those shapes or hold this book at arm's length. Pay particular attention to the triangle and the circle—in which set do all three shapes appear the same size?

The difference is slight, but, thanks to overshoot, set 2 looks more equally sized than set 1.

Typographers use overshoot in their day-to-day production of commercial typefaces, and so too can we use overshoot in our day-to-day lettering. Overshoot applies to all kinds of letters: sans, serifs, scripts, you name it!

> "We read with our eyes, not with rulers, so the eye should win every time."
>
> Tobias Frere-Jones, "Typeface Mechanics: 001"

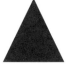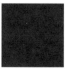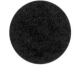

SET 1 All of these shapes are 0.75" tall and are mathematically aligned.

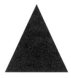

SET 2 The triangle and circle have been slightly enlarged and are optically aligned.

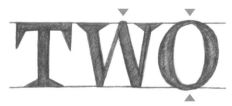

See those little spots where the pointed and rounded characters extend beyond the baseline and cap height? That's overshoot. If the *W* and *O* didn't have overshoot, they'd look smaller than the *T*, and our eyes would notice.

We read with our eyes, not with rulers.

Do your letters have

endo

bones on the inside?

OR

exo

bones on the outside?

Different Strokes

Before you get started, here are three drawing techniques you should know: drawing with a single stroke and drawing what I'm calling "endoskeleton" and "exoskeleton" letters.

Single-Stroke Letters

Making letters with single strokes sounds simple, but it's perhaps the most challenging way to letter. Making letterforms out of one, two, or three strokes takes months, sometimes years, of practice to achieve the manual control to "get it right." Sign painters, who typically specialize in single-stroke letters, go through multiyear apprenticeships to hone their skills.

If that's not your thing, no pressure, but it's still worth a try! The single-stroke method can be a very meditative practice. Try repeating a single letter, making incremental improvements. Draw lines in the sand with a stick. How about a water hose on pavement? Any practice is good practice.

Endoskeleton Letters

Endoskeleton letters, or single-skeleton letters, are what they suggest: letters created by first drawing a central spine that provides a rough idea of the letter's size and placement before adding weight or decoration.

First, draw lines that run down the middle, or spine, of the letter. Then, add substance and weight to those letters. Here's where tracing paper comes in handy. Try drawing the spines of the letter on a sheet of paper and then draw the bulk of the letters on an additional sheet of tracing paper. You may have to adjust and respace your letter forms—and that's okay.

Exoskeleton Letters

Alternatively, you may want to start by drawing the outer edges of the letterforms to make exoskeleton letters. Work from left to right, drawing the contours of each letter. As shown in the example below, it's good practice to extend your lines beyond the edges and corners of letters. You can erase those marks later. Once you've got your letters how you like them, fill in the "guts" of the letterforms. From there, you can add embellishments like serifs and flourishes.

Which technique do you feel most comfortable trying? Were you already using one of these techniques in your own lettering?

Single stroke: one and done!

Endoskeleton: first, draw the spines, then add weight on either side of the spines.

Exoskeleton: start with the edges, then fill in.

Spacing and Planning

One of the most challenging parts of creating a harmonious piece of lettering is kerning, or letterspacing. It takes practice, tracing paper, and lots of sketching to get the spacing between each pair of letters juuuuust right.

If precision isn't what you're going for, that's A-OK. You're free to letter as fast, as slow, as clean, as messy, as weird, and as wonderful as you like. But if your lettering needs some fine-tuning, here are a few spacing-related steps to polish your lettering to a sparkling finish.

Hash Marks before Pen Marks

Before you go in with pen, ink, or permanent marker, it's good practice to pencil in guidelines (from page 17) and hash marks. Hash marks, in this context, are vertical lines that demarcate where each of your letters—and the space between them—will exist.

Spacing Is a Mood

We've already established that tools can influence tone. Typographic variables, as well, can contribute to how your letters communicate (see next spread). But there's yet another element that determines how your lettering communicates: letterspacing.

There are two terms used in the world of typographic spacing: *kerning* and *tracking*. Kerning refers to the space between two letters. Tracking is the space among a grouping of letters.

WHOA

W H O A

Say each of these "whoa"s out loud. How does your voice change?

Refining Is Fine Work

That's what tracing paper is for! Let's say you've made your best-laid plans and drawn all your guidelines and hash marks. Maybe you just don't hit the mark the first go. Not to worry! Grab your tracing paper and draw over what you've previously drawn. Maybe your *W* got a little too close to your *H*. Tracing paper allows you to manually kern your letters.

If you really want to practice your kerning, cut out each letter on its own piece of paper and move the pieces around on a tabletop like puzzle pieces.

clean

clean

So, why care about spacing your letters?

It all comes down to intention. Tightly or irregularly spaced letters feel tense. Even, balanced spacing is easy on the eyes and highly legible. Both are effective in communicating a message or a feeling, but you, as the letterer, have the responsibility of making that choice. It's what makes the difference between **dean** and **clean**.

inconsistent letter width?

HAS THIS EVER HAPPNEED TO YOU?

awkward spacing?

misspellings?

Weight

Think gravity. In reference to letterforms, weight is the relative thinness or thickness of a letter's stroke—how "light" or how "bold" a letter is. Letters with thin weights appear visually lighter and can be perceived as delicate or sophisticated. Bolder letters are associated with confidence, as they typically speak the loudest and can dominate the page.

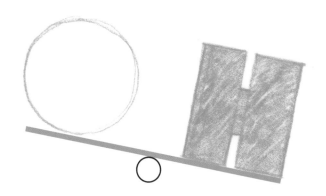

Typographic ←

Contrast

Contrast refers to the difference between the thinnest and thickest parts within an individual letter. Contrast is often influenced by the size and shape of your drawing tool—flat-tipped pens will create high-contrast letters, whereas a no. 2 pencil will create lower-contrast letters. At right, notice the difference between the thickest part of the letter and the thinnest part? That's contrast! Letters with a completely consistent stroke weight, or "monoweight," are called "monoline."

Width

Width refers to—you guessed it—how wide or how narrow a letterform is on a horizontal axis. Extremely wide letters are known as "extended," while narrow letters are known as "condensed" or "compressed." Traditionally, newspaper headlines use condensed typefaces in order to fit more letters per line within narrow newspaper columns.

Variables

Decoration

Flourishes, ornaments, and swashes, oh my! Adding decoration is the most obvious way of adding personality to letterforms. Visual elements like lines and inlines, drop shadows, prisms, flourishes and swashes, and illustration are just a few ways to add interest. How can you push the limits of embellishment? Ready to get ornamental? Head to page 81.

Serifs

A serif is a small line or protrusion attached to the end of a larger stroke of a letterform. Serifs can take on many different shapes, sizes, and proportions—each communicating a distinct attitude and emotion.

What Do Serifs Do?

Serif typography has a calligraphic heritage—the angles, movements, and flicks of the pen dictated the shape of the serif. The serif functioned as a mechanical starting and stopping point in the stroke. Think of it like the windup and follow-through of a baseball swing.

From a typographer's standpoint, the serif can define an entire typeface. Typographer Hannes Famira says that serifs indicate the "transition of visual weight" in a typeface—they define the thicks and the thins. That is, if a serif has high contrast and individual letters have high contrast, this gives visual balance to each letter and unites all the letters in an alphabet.

Essential or Ornamental?

By the eighteenth and nineteenth centuries, the shapes of serifs became divorced from their original calligraphic intention and instead became decorative, expressive— even wild. Italian designers took on a practically pictorial perspective. For more on this, see page 81, "Get Ornamental."

In the 1920s, Bauhaus designer Herbert Bayer proposed an alphabet that he considered to be ideal. Sans serif, lowercase, minimal, and rooted in geometry, Bayer's design strips down letterforms to their most basic and necessary shapes. If you fancy a Spartan and minimal approach, feel free to jump to page 128 and "Make It Minimal."

The Great Debate

Is serif type easier to read? It depends on whom you ask. Over centuries, readers became accustomed to the way printed typography looked, and thus, a visual precedent was formed.

Jump ahead several hundred years to the advent of screen-based typography, and suddenly, you see almost exclusively sans serif type. The simpler forms of sans serifs were easier for square pixel-based screens to render.

Some proponents of the serif say that the shapes of serifs help your eye travel across a line of type. This is why serif type is a practical choice for newspapers, books, and magazines. Sans lovers will argue that the simpler forms of sans serif letters allow for a cleaner and quicker read with a more contemporary feel.

Addressing Audience

When you're deciding what to letter, think about whom your lettering is for. If you're creating lettering for an antiques dealer, serifed letters may be the right way to go. If your lettering will be used in a children's book or elementary classroom, you might consider drawing sans serif letters. Why? Serifs are an extra level of detail, an extra level of complexity. For little ones learning to read, simpler forms may be more ideal for legibility.

Remember: Serifs should never be an afterthought! The style and quality of serif can influence the meaning of the word and the tone of your lettering.

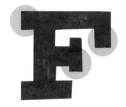 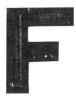

See the extra bits on the *F* to the left? Those are serifs. The *F* in the middle doesn't have those bits—it's classified as a "sans serif."

Four Common Types of Serifs

The Hairline
Fine as frog's hair! These serifs are thin and linear, often in high contrast to the rest of the letter. Fonts for reference: Bodoni, Didot.

The Bracketed
Bracketed serifs have a connection slope that joins the serif to the stem of the letter—just like a bracket for a wall shelf. Fonts for reference: Baskerville, Perpetua.

The Slab
Think about a slab, or block, of stone. These serifs are defined by their flat, rectangular shapes. Fonts for reference: Archer, Rockwell.

The Tuscan
There are many, many different types of Tuscan serifs—from wing-shaped to palm-shaped. How do you spot one? Look for pointed, bouncy forms that extend out and away from the stem. Fonts for reference: Antique Tuscan, Yana.

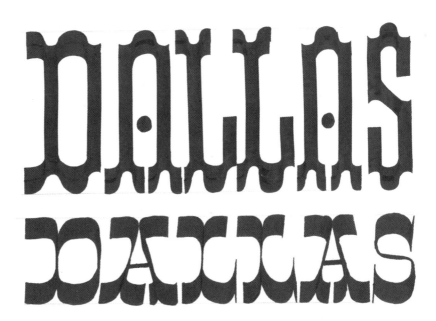

→
James Edmondson

Ready your pencils! Use simple techniques to learn the fundamentals of drawing letters. Learn tips and tricks. Experiment with different ways of drawing to push your letterforms.

2

draw

Get a Feel for Form

What do Pablo Picasso, William Faulkner, Igor Stravinsky, and Steve Jobs have in common? Each is credited with saying the infamous "Good [artists] copy, great artists steal." Does this give us permission to steal each other's work? Certainly not.

Artist Adam J. Kurtz clarifies: "'Great artists steal' is at its root about finding inspiration in the work of others, then using it as a starting point for original creative output. Artists may recontextualize, remix, substitute, or otherwise mash up existing work to create something new."

→ Use your tracing paper to trace the letterforms printed here. The word *trace* here can be used loosely—use any tool or material to follow the contours of the letters. Consider this exercise a source of inspiration for your own lettering.

a

k f

i

q i w j

z

o e

Consider using different tools for different letters!

u n i

Patient Scribes and Pen Strokes

You're in a quiet room, the walls lined with stone. It's midday, cloudy. Inside, the only light comes from your candle. Books surround you, and piles of parchment cover your desk. You see a small dish for ink and a quill within arm's reach. Line by line, letter by letter, column by column, you work to document the treasured texts of your day.

Many advances in writing have been made since the Middle Ages and the days of scroll and quill, but the influence of this style of writing is ever present in the typography and lettering of today (more on that in the next exercise).

This style of writing is what we tend to think of as calligraphy. Careful, methodical strokes, fit for a fantasy adventure or religious text. The attempt to achieve perfection using only a modest writing instrument and container of ink. Orderly forms, fit for holy orders.

Calligraphic writing instruments like feather quills, used by scribes and calligraphers throughout the ages, could be categorized as flat-tipped pens—as opposed to brush tips or modern-day ballpoint pens. Flat-tipped pens create lines of different thickness: held one way, the pen can make thin lines; perpendicularly, it makes thick lines. Writing with this kind of pen has a distinct modulation in the stroke. It's iconic!

→ You may not have a quill, but you might have a calligraphy pen! Acquire a flat-tipped calligraphy pen—5 mm is a good place to start. Then, holding your pen at a fixed angle, follow the path of the letterforms to the right. You can use a sheet of tracing paper to draw over the letters. Do your best to mimic the letterforms. To focus on particular kinds of strokes, try drawing letters in groups by their structural styles. That's how typographers do it!

This exercise is one that involves muscle memory. The more you draw straight lines, the better you'll get at drawing straight lines. Now's your chance to mimic monks of old—without the unfortunate hairstyle!

No calligraphy pen? No problem. Try taping two pencils together. The resulting strokes will mimic a wide calligraphy pen.

Structural Styles

The Uprights

ILTHEFJ

The Rounds

OQCDG

The Half-Rounds

BPRSU

The Obliques

VAWKM

YXNZ

RUNNING·A·TIGHT·SHIP·EVERY·DECKHAND·HERE·HAS·A·FIVE·YEAR·PLAN

I'VE·BEEN·DRAWN·TO·WHAT'S·TIED·TO·THE·TRACKS

ALWAYS·FELL·FOR·A·WOMAN·BEING·SAWN·IN·HALF

A STRANGE ADDICTION FLIPPING IN A STRANGER FICTION

no·luck·just·fortified·dice

a revolution of stillness

marching · THE of·mannequins

CHILDREN OF THE CORN SYRUP

NO·KINGS·NO·KINGS

WHO·HAS·NEVER·KILLED·AN·HOUR·NOT·WITHOUT
THOUGHT·BUT·A·PREMEDITATED·MURDER·OF·MINUTES

LISTEN FOR YOUR TRUE GODS

the·silhouettes·are·fencing·lefty·scissors

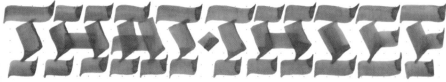

THAT·THIEF

BOSS IS A BIT SCARED OF THE FLOCK · BOSS IS A BIT SCARED OF THE FLOCK

↑
Kelsey Elder

Alternating Axis

Now that you've practiced your classical calligraphy skills, it's time to change things up! This exercise invites you to play with different axes, or different angles, at which you hold a flat-tipped pen.

Historically, calligraphers and letterers have held their pens somewhere between 30° and 45° to construct visually pleasing letters. And this tradition is evident in modern-day typefaces. How? Typefaces like Sabon, designed by Jan Tschichold, are classified as humanist. Humanist typefaces have letterforms that look like calligraphy, as if written by the human hand. But the human hand has many capabilities and variations!

→ Using a 5 mm calligraphy pen— or something similar—write a word using the traditional 30° angle. Maintaining a consistent angle across an entire word can be tricky for beginners, so you may have to give it a few tries. Once your 30° word is complete, write the same word again but shift to a 45° and then a 90° angle. Changing the angle of the pen changes where the contrast lies in your letterforms and influences the shape of the terminals (the end of the strokes). Bottom line: the angle at which you hold your pen determines how your letters will look. How else does the visual expression of the word change, based on where the thicks and thins are located?

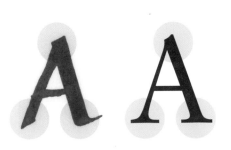

These two *A*'s—one from the previous spread (left) and the other in the font Sabon—both show their roots in writing with a flat-tipped pen. Look, too, to the terminals of the letterforms. How are they different? Can you discern the angle of the pen from the shape of the letters?

↑
Here, designer Kelsey Elder has held his pen at 90°— the thickness lies in the horizontal strokes and the thins in the vertical.

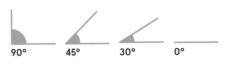

90° 45° 30° 0°

The angle at which you hold your pen determines how your letters will look. Line up your pen with one or more of these angles, above.

Make It Bold

Find a letter to use as your base letter. Ideally, choose a letter in a "regular" or "thin" weight. You can source a font or draw one of your own letters.

Lay the tracing paper on top of the letter and, with your pencil, demarcate your baseline and cap height. Then, trace the left sides of the letter. Imagine a light shining on it from the left; anywhere light would touch, draw that contour.

Now that the left and right sides of your newly widened letter have been drawn, connect any remaining line segments. These lines will mainly be horizontal strokes at the top or bottom of the letter.

2

Then, keeping your baseline steady, move your sheet of tracing paper to the right. The farther to the right you move it, the bolder and wider your letter will become. Now, trace the right edges of the letter.

4

Fill in your finished letter!

The late typographer Gerard Unger, who's quoted several times in this book, developed this simple process—aptly named the Unger Method— for making letters bolder, using only tracing paper and a pencil.

Sense of Scale

Imagine a shoe the size of a city block. Now imagine a humpback whale the size of a coin.

As humans, we are accustomed to seeing and interacting with objects and spaces that are designed for us, relative to our size. Changes in scale can be a shock to the system! We typically encounter letterforms in books, on products, and on posters—letterforms usually no larger than the palm of our hand. Even when we see letters on large outdoor advertisements, the distance from which we read them makes them feel small.

But imagine standing next to one of such towering billboard-size letters. You'd be able to see details in the curves, corners, and serifs that you may not have noticed before. Changes in scale change our perceptions.

Readable Ranges
The general rule for letters is that for every 1 inch of height, you get 10 feet of readability. For example, letters that are 6 inches high are legible at 60 feet—that's about as long as a bowling lane!

→ For this exercise, you'll change your perceptions and increase your appreciation for a letterform by drawing it BIG. Search for a letter in your environment. Books and packaging are great places to look. Examine the proportions and details of your found letter. Seek out a pencil and a big piece of paper—at least 18 by 24 inches—and start drawing! Marking in baselines and cap height lines can help you get started.

Once you've drawn it big, why not make it bigger? How about 5 feet tall? Even bigger? The team at 530 TypeClub isn't afraid of scale! Check out their larger-than-life letters to the right.

Rulers and straight-edges can come in handy here. Even with rounded letters, drawing in your baselines and cap heights can help you understand a letter's geometry.

Using tape as a medium, participants in this workshop were asked to create the biggest letter possible! Once the letters—like this Y—were created in physical space, they were photographed and redrawn digitally.

↑ →
Workshop run by Prang Sayasilpi and Jonathan van Loon, 530 TypeClub

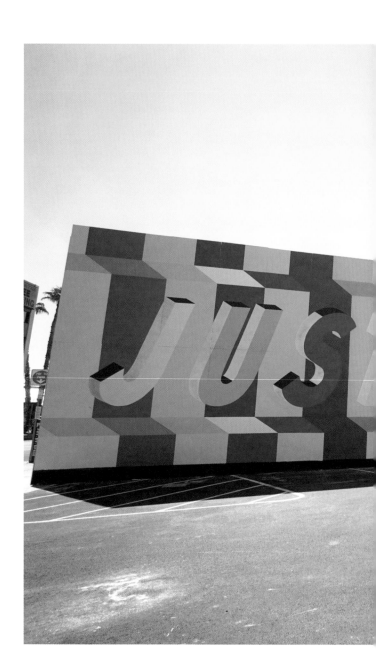

→
Just Passing Through
Lakwena

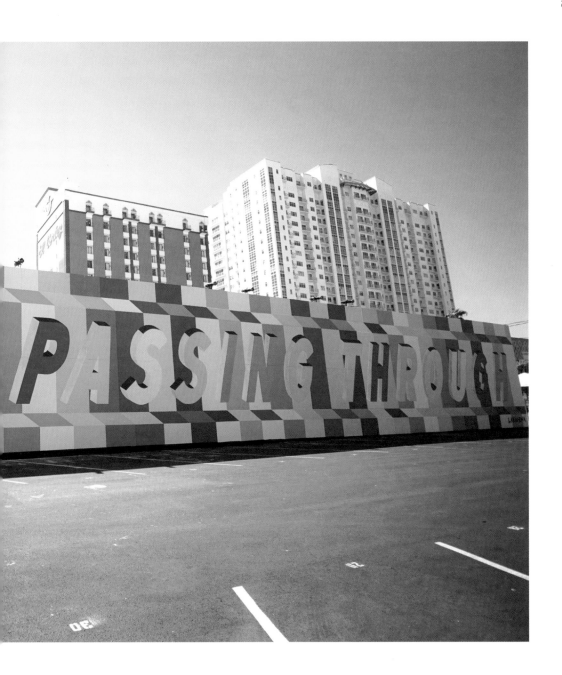

Cut Corners

Don't let this exercise make
you sleepy.

Imagine a bed with two pillows:
one of those pillows is made of
down feathers and soft fabrics, the
other of brick and mortar. Which
one seems more inviting? Which
would you rather lay your head on?

You don't have to lay your head
on a pile of bricks to realize that
softer, rounder forms are perceived
as being more inviting. The same
could be said for typography. It's
almost instinctive!

Shape Sensations

Have you ever heard of "Bouba"
and "Kiki"? Which of the two
words sounds soft and squishy?
Which sounds pointy and rigid?
Did you think "Bouba" sounded
softer? You're not alone! In 2016
scientists re-created a ninety-
year-old experiment using these
word-shape-sound associations
with participants who were
native speakers of English and
Chinese. Their results showed a
shared "linkage between visual
and auditory processing" among
the participants regardless of their
native language.

→ Create a "Bouba"-like alphabet
or group of letters that have no
hard edges or corners—letters
worthy of an afternoon nap.

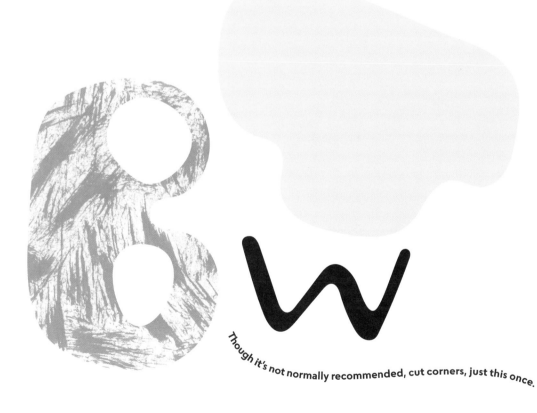

Though it's not normally recommended, cut corners, just this once.

mardi 26 mars
20h30 5€
repas prix libre
GZ HLM
présente
un solo
néo-zélandais
de drone folk
et un solo
villeurbannais
d'harmonium

infos sur
jesuisanxieux
@gmail.com

↑
Félicité Landrivon

Two Points

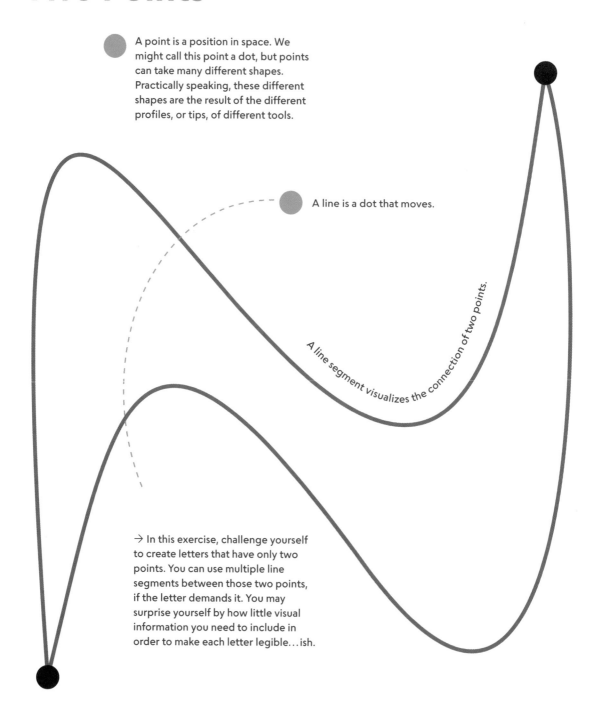

A point is a position in space. We might call this point a dot, but points can take many different shapes. Practically speaking, these different shapes are the result of the different profiles, or tips, of different tools.

A line is a dot that moves.

A line segment visualizes the connection of two points.

→ In this exercise, challenge yourself to create letters that have only two points. You can use multiple line segments between those two points, if the letter demands it. You may surprise yourself by how little visual information you need to include in order to make each letter legible…ish.

Conditional Lettering

American artist Sol LeWitt is known for following strict rules to create his wall-size drawings. Here's an example:

On a wall surface,
any continuous stretch of wall,
using a hard pencil, place
fifty points at random.
The points should be evenly
distributed over the area
of the wall. All of the
points should be connected
by straight lines.

These rules or conditions did not restrict LeWitt's creativity—they actually helped to focus his drawings. He wouldn't have to think about what tools to use or what colors to use, freeing his brain to create in other ways.

Designing or lettering with strict rules is called "conditional design." You might argue that every exercise in this book is conditional!

Use the template at right yourself or challenge friends to make their own conditional lettering.

Create your own Conditional Lettering Statement

On _____ ,
surface

use _____
tool(s)

to create _____ .
shape/form

Your _____
shape/form (same as above)

should be _____
quality/function

and every _____
shape/form

should _____ .
quality/function

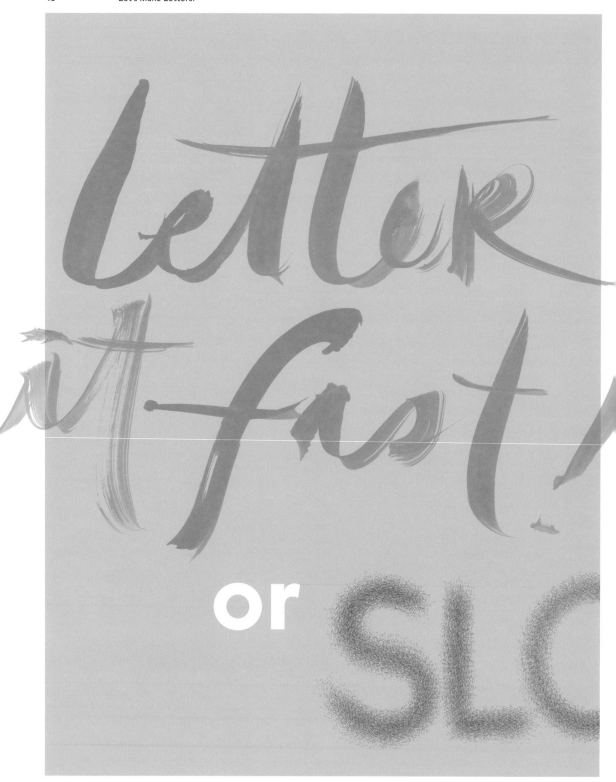

Letter It Fast or Slow

Just as changing tools and implementing rules alter the way we letter, so, too, does changing the tempo.

What does speed do? It can make things bend and fracture, streamline and plane, even break the sound barrier!

In typography, when we think of speed, we can't help but think of italic typography. The forward slant of italic letters exudes forward movement.

→ Set a timer for thirty seconds, one minute, and two minutes. Letter the same word or phrase within each duration. How does your lettering change? Which piece of lettering do you like best?

Lettering fast is a good way to get ideas out of your system, out of your brain, and onto the page. Go, go, go!

Fast may be fine, but some things just take time.

What can slowness give? Natural processes in our world often require time to take place—like growing grass or mold, a caterpillar turning into a butterfly, or birds evolving from dinosaurs. Creatively speaking, being slow can force your mind and body to relax. It can allow you the time and space to be more accurate, maybe more intentional.

→ Set a timer or a reminder, this time for three hours, three days, and three weeks. Letter the same word from the fast exercise, but this time, work on it gradually throughout the allotted durations. In this case, it's not about winning the race.

Fast Stuff:
— hummingbirds
— Formula 1 race cars
— fireworks
— rockets
— cheetahs
— tuna

Slow Stuff:
— baking bread
— walking in a forest
— staining a deck
— curing meat
— growing a plant from seed
— drying paint

Straight Lines Only

What would an alphabet look like with no curves? Would we still be able to recognize our curvilinear characters?

The twenty-six letters in our alphabet are made up of straight lines and curves. The straight lines of an *H* are different from that of a *C*, which is different from an *M*, and so on. When we're learning to read, we're learning to memorize the shape of each letter, how each letter sounds, and how to string the letters into words, then learning what those words mean.

As page 35 suggests, when type designers begin drawing letterforms, they don't draw in "ABC order," they divvy up letters based on their visual similarities—grouping straight letters like *H*, *T*, *I* and round ones like *C*, *Q*, *O*.

↑
Max McCready

→ You know what's coming. Using a tool of your choice, create an alphabet or a series of letters using straight lines only.

ABCDEFGHIJKLM
NOPQRSTUVWXYZ
abcdefghijklm
nopqrstuvwxyz
0123456789

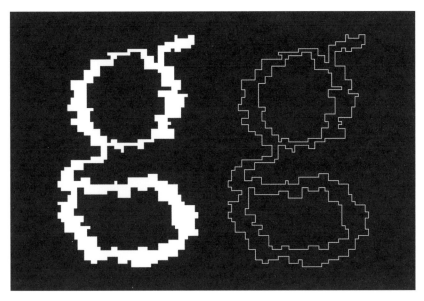

↑
Carter Pryor

Arcade Alphabet

We've tackled points and lines. Now, let's try our hand at squares.

In this exercise, we'll be dealing with a familiar pastime in an unfamiliar format—you're going to draw pixelated letters on paper.

Contemporary video games have flashy graphics and realistic renderings. But that wasn't always the norm! In the 1980s and '90s, game designers were constrained by the limited hardware of the day. Arcade machines and home consoles had only so much memory, could display only so many colors, and could have only so many elements on a screen at one time. Letters, like any other pixels, were precious data. And still, game designers found inventive and artful ways to tell stories and display fun and inviting digital spaces.

"In the old tile-based graphics systems, you needed to make fonts from as few as eight-by-eight pixels," explains typographer and arcade game aficionado Toshi Omagari. "This is a tiny canvas upon which to design a typeface." Within this sixty-four-square grid, designers had to find a way to create the full gamut of both Eastern and Western character sets. For games released in North America, that meant twenty-six letters, ten numerals, and assorted punctuation marks, each occupying about forty-nine of those sixty-four squares, with rows of blank squares to allow for spaces between letters.

The eight-by-eight grid was the norm, but that didn't stop game designers from playing with different pixel ratios for different kinds of typography. For example, an eight-by-eight grid produces squarish letters, whereas an eight-by-sixteen grid yields condensed, thin letters.

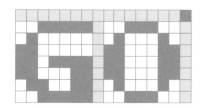

→ Put yourself in the pixels of a game designer during the golden age of the arcade. What kind of game are you making? Swords and sorcery, perhaps? Then, determine your grid ratio; see a few examples below. Now it's time to color in some squares! Start with the letters *A, H, O, R,* and *M*. Once you've got those foundational letters down, you can use them as the basis for all the remaining letters. Do your best to match your lettering with your chosen game genre.

Choose your own grid!

8x16

16x16

8x8

4x4

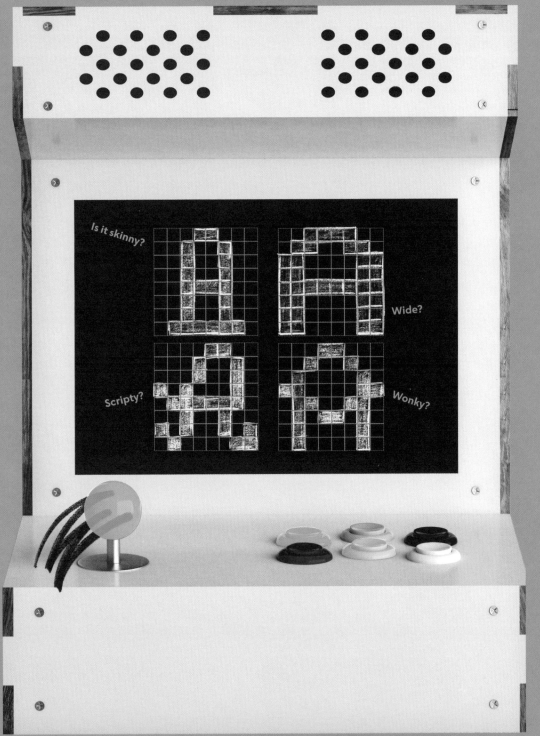

Is it skinny?

Wide?

Scripty?

Wonky?

→
Carter Pryor

Draw with your body

If each of these letters were a dance, a gesture, a yoga pose, what would they be? How would you move? Get movin'!

Make It Modular

Move beyond the restrictive eight-by-eight grid of Arcade Alphabet and open your eyes to the possibilities of modular typography of all shapes and sizes!

Modular typography creates letterforms from a specific, restrictive set of shapes, or modules. So, with very few shapes, you can make very many letters. You can build a modular system.

→ Get modular! Create a series of shapes, or modules. How could you combine those shapes to create a few characters of the alphabet. Start drawing with a letter from each structural style (see page 35). For example: *H, O, M, R, A*. Once you find solutions for these letters, you should have an idea of how other similarly styled letters will behave.

Then, repeat those shapes to form more letters. How can you repeat certain shapes to create common forms in your alphabet? How many shapes do you need to create a letter?

Will you make an uppercase or lowercase alphabet? If this is your first time creating a modular typeface, consider working with uppercase. The shapes are fairly rigid and repeatable. Lowercase letters have more complex shapes.

The classic module should follow a universal geometry: squares, circles, lines. Or at least that was the thinking of the members of the Bauhaus—the influential German design school that operated from 1919 to 1933, graduating many celebrated designers. One such designer, Herbert Bayer, created a lowercase modular typeface called Universal that's made exclusively of straight lines and semicircles. Another Bauhaus designer, Josef Albers, created a modular typeface called Kombinations-Schrift that used a similar geometric letter-making method.

One more thing: pay attention to symmetry. Once constructed, some letters can be simply rotated or reflected to form other letters—like *b* and *d*.

↑
Jocelyn Yun

Vanna Vu

Incorporating Inlines

Inlines are linear decorative details added within the body of a letter that lighten the overall visual weight of the letterform. They also add an extra level of detail that can make your letters feel special. Inlines, especially the hairline and bulb variations, may remind you of diner or movie theater signs. That's because these lines and dots share a similar form to the

physical light fixtures used in the production of those signs. Do any of the variations to the right remind you of anything else?

→ Source some sans serif lettering. You can even trace existing fonts or lettering you've done in the past. Start with hairlines and then move on to more complex variations.

A thin line, or hairline, that travels along the center of a letter is the norm, but inlines have seemingly no bounds!

→
Zrinka Buljubašić

Common Types of Inlines

Hairline

Dotted or Bulb

Fade

Thick

Glare Lines

Multiline

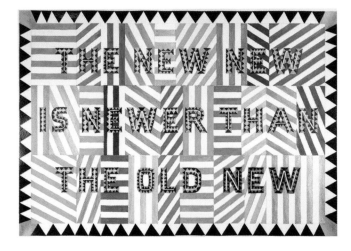

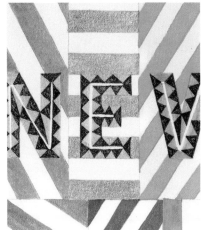

↑
Marian Bantjes

Perimeters as Parameters

Starting with shapes can help give your lettering structure and context.

How so? Let's say you want to letter a logo for a new ramen shop opening in your town. Certainly, you could letter some wiggly monoline letters that look like noodles. But what if you put your lettering in a container that was wavy—so the letters move together in a unit to fill a wiggly shape?

→ To start, draw at least five different shapes to act as your containers. Then, choose a word. It could be the name of a restaurant, a city, an animal, you name it! Within those shapes, draw either (1) the same word in each container, or (2) a unique word for each container. Does the word communicate something different when it's lettered within different shapes?

Try to make your letterforms follow the edges of the object, bearing in mind overshoot for rounded characters.

→→ Anna Sing

→ Ola Niepsuj

↓ Ian Lynam

←
Julia Rumburger

↓
Onanma Okeke

↓↓
Marco Cheatham

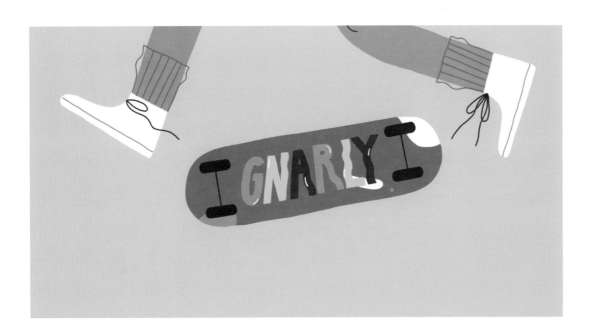

Containers as Composition

The previous exercise primarily dealt with one word, one container. This approach is great for applications like logos, where viewers have one moment, one impression of the work. Instead of drawing one singular word or letter, this exercise asks you to use containers as a tool to create hierarchy among multiple words in a piece of lettering.

Hierarchy, in this case, is the order in which the viewer sees and reads your lettering. As letterers, we have the amazing power to encourage people to read our work in a certain order. What are the parts that need to be lettered? What ought to be the main focus of the reader's attention? How do the parts that are not the main focus relate to the part that is?

→ Gather your content. In the example below, we're creating a title block for a late-night TV show. Once you have your content, start small. Make multiple small sketches (around 2 to 3 inches high) of your content; these are called thumbnail sketches. Experiment with each of the different strategies at right for creating hierarchy. Which version communicates your idea best?

Don't forget your baseline, x-height, and cap height lines! And hash marks!

↑
James
Edmondson

Use what you've learned from "Perimeters as Parameters" to create dynamic shapes for your lettering.

Strategies for Creating Hierarchy

say
cheese!

Scale

Our eyes will typically gravitate toward the largest object on the page. Consider which word is the most important—does it need to be the largest element?

say
cheese!

say
cheese!

Color

In our visual landscape, the human eye is most likely to notice red and yellow; blue and green are more likely to recede. Color can have a huge influence on the order of what we see.

Placement and Position

In Western culture, we read left to right, top to bottom. That means lettering at the top left of your composition will be read first. Be intentional about word order.

say
CHEESE!

Style

Difference in styling means difference in importance. Does your lettering incorporate both a sans and a script? How does this difference in style change how we read?

say
cheese!

Proximity

The distance between objects: words placed close together, or grouped, have a close relationship to one another. Words that are spatially separate can feel contextually separate.

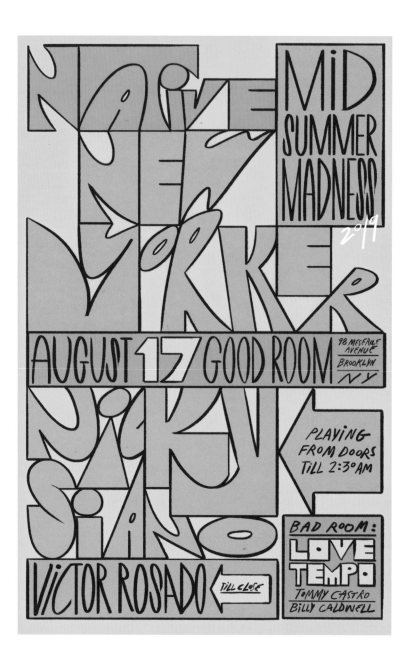

→
Bráulio Amado

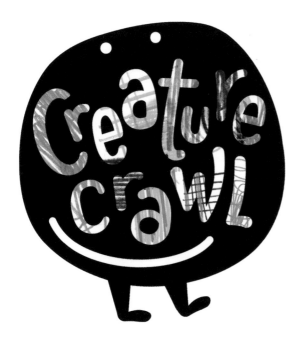

←
Museums around Southern California initiated a campaign called Creature Crawl for kids and families to hunt for various creature body parts by visiting as many museums as possible. Collected creature parts make up a paper creature for coloring.

Happening Studio
Client: SoCal Museums

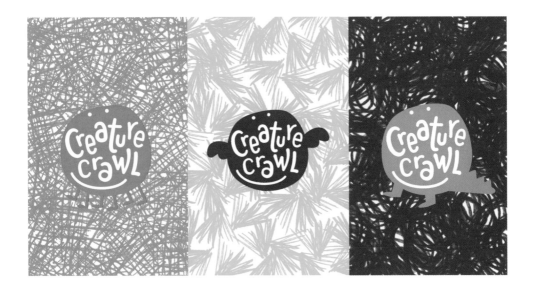

↑ →
Nolen Strals

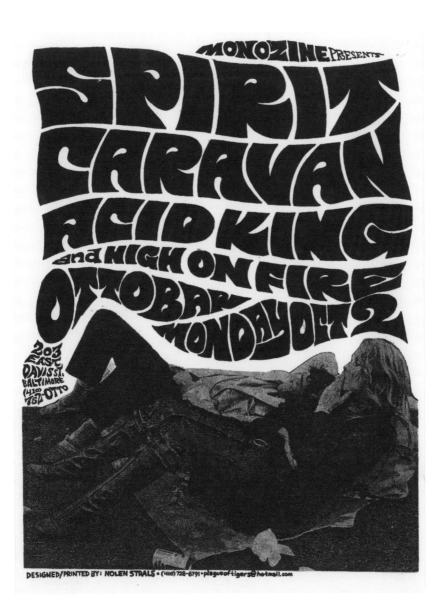

Dimensional Lettering

Dimensional, or 3D, lettering can appear daunting to beginners. Most letters aren't perfect geometric shapes: they have lots of ins and outs, holes, and complex curves. Drawing letters in 2D space can be challenging enough, right?

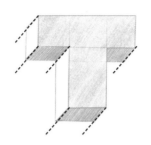

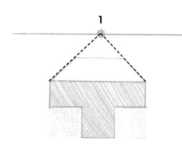

Never fear. The foolproof method for drawing dimensional letters is to use the basics of perspective drawing. Traditionally, perspective drawing has been a method for artists and drafters to accurately depict still lifes, buildings, and, generally, any object in space, relative to a horizon line.

Start all of these exercises by imagining your word or letter existing within a 3D rectangular shape or cube.

Simplified Perspective

This kind of perspective drawing is just that: simple! If you can draw diagonal lines, you can draw a letter in simplified perspective.

→ Start by drawing a rectangular letter, like *T* or *H*. Decide on an angle upon which your letter will extrude—a 45° angle is a good place to start. Then, draw angled lines from all corner points. Keep your angles consistent and your lines parallel, and be sure to draw lines that are equidistant from the letter. Complete the dimensional letter by connecting the ends of your angled lines with vertical and horizontal strokes.

If you're new to perspective drawing, try starting with simplified perspective and then move on to one-, two-, and three-point perspectives.

One-Point Perspective

Imagine you're driving down a straight, open road in the countryside. The landscape spreads out in all directions, but if you look forward, you'll see that the road narrows as it gets farther away from you, until it vanishes. This spot at which the road vanishes at the horizon is called the vanishing point. One-point perspective seeks to capture that visual phenomenon.

This is a frontal way of drawing a flat letter that extends straight back into space.

→ Start lettering. If this is your first time trying this technique, your lettering should consist of mostly square letterforms. Draw a horizon line and a single vanishing point. Then, draw your letter above or below your horizon line. From the outer contours and corners of the letter, draw lines that connect your letter to your single vanishing point. Complete the letter by drawing horizontal strokes at your desired depth.

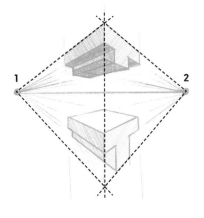

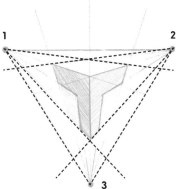

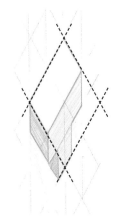

Two-Point Perspective

Imagine yourself in the city, standing on the corner of a four-way intersection. You look diagonally across the intersection and see a building about four stories tall. Instead of just seeing the front of that building, you're seeing a corner view with two sides of the building. These two sides move backward in space to two vanishing points—hence two-point perspective.

If you want to be able to see two different faces, or sides, of your lettering, two-point perspective is the way to go.

→ Start with your horizon line, with a vanishing point at each end of your line. Next, draw a vertical line either above or below the horizon. This will help determine the height of your letters. From the top and bottom of that line, draw two lines moving back into space, connecting with your vanishing points. This dimensional box will act as the container for your letterforms. As you draw, be sure to connect all corner points with your vanishing points.

Three-Point Perspective

We're back in the city again. Imagine you're standing at that same intersection, but this time, you're on the roof of the building. You look, again, diagonally, and you see three faces of the building moving back into space—the left facade, the right facade, and the roof.

As you might have guessed, three-point perspective requires three distinct vanishing points that determine the direction of the planes as they move back in space.

→ Start with your horizon, then mark your vanishing points—one on each end of the horizon line and a third point above or below the horizon line. The closer your third point is to the line, the more drastic your perspective will appear. Draw guidelines connecting all your vanishing points. Just as with two-point perspective, be sure to connect all corner points with your vanishing points.

Isometric Perspective

Isometric drawing is a different kind of perspective drawing that doesn't distort the proportion of your letterform. Nor does it follow any vanishing points. See those diagonal grid lines? They're parallel, meaning that they keep going on forever and never touch.

→ Start with the grid. Draw a single vertical line. Then draw two additional lines that crisscross on top of that vertical line (0°). Your diagonal lines should be precisely at 30° and -30°. A ruler and protractor can be helpful here. Moving outward from this central intersection, continue drawing parallel lines at 0°, 30°, and -30° until you have a network of lines. Once your grid is in place, lettering is just a matter of drawing over your grid lines!

Dimensional Lettering: Use the Camera as a Tool

Let's say you've got a piece of lettering you've already completed, but you want to make it dimensional. Lay your lettering down on a tabletop and grab your camera or phone. Lower your phone to the tabletop and watch how your letters become spatially distorted in single-point perspective.

Phone

Do phones even look like this anymore?

a

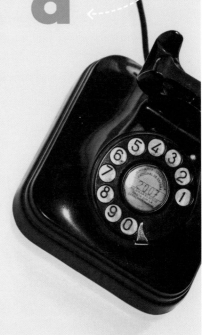

→ Grab a pen and paper. Pick up
the phone. Call somebody. Draw
type while you talk. Don't think
about it.

Friend

↑
Annik Troxler

Continuous Line

From city block to country road, chances are you've seen a neon sign. These ubiquitous signs are defined by bright colors, welcoming messages, and, most notably, their continuous, connected linear neon light tubes. The production of neon signs is fascinating; remember that glassblowers and neon fabricators are limited by the constraints of glass as a physical medium—it can only bend so far, creating soft curves.

→ You know what's coming: select and challenge yourself to create a letter made from a single, continuous line. Once you've tackled a single letter, expand your range to other letters to form a word or even a full alphabet. Then, move on to words or phrases.

Materials like wire have a similar tensile strength, but wire, if bent too far, can snap in half. If you were to replicate neon sign lettering with string, you'd be able to recreate it well, but it wouldn't be stiff enough to hang up in a window.

What about yarn? A piece of flexible bamboo? A scarf? Even though these stringy things don't glow like neon, they all share a similar physical property—they're one continuous line.

Designer Vanna Vu explores the potential of a set of characters that could be formed from paper clips.

Vanna Vu
↓

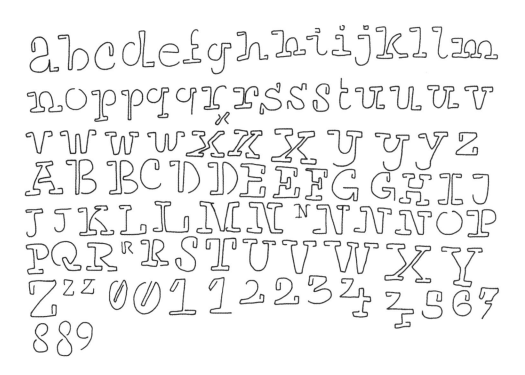

Feeling adventurous? If you're drawing with pencil or pen, don't lift your pen off the paper. For an added challenge, don't even look at the page as you draw!

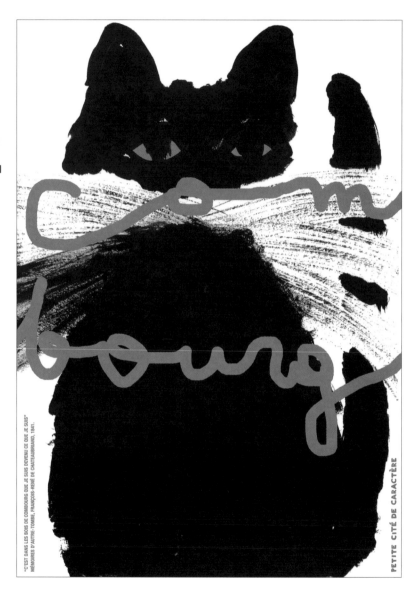

↑
Zofia Klajs

←
Cheryl D. Holmes Miller

Draw a letter with your non-dominant hand.

Matchup Monogram

A monogram is a symbol made up of two or more letters. From logos to bath towels to paintings to garments, monograms signify ownership and identity—the letters are unique to the individual or organization that uses them.

The original Greek meaning of the word *monogram* is "single line," something drawn in outline.

Monograms as we know them were possibly first used around 500 CE by Justin I, emperor of the Eastern Roman Empire, who couldn't read or write, to sign his name. In the Victorian era, monograms were used by the nobility to claim their pos-sessions, as a status symbol to prove their wealth. They'd apply their personal, or their family's, monogram to everything from linens to wax seals to be used in correspondence.

Famous artists have long used monograms as a way to sign their work. German painter Albrecht Dürer, for example, has one of the most recognizable insignias.

In Eastern cultures, personal monogram seals, commonly called chops in the West, have been in use for thousands of years. These small objects are typically made of stone, wood, clay, or bone and feature the owner's initials carved into one end—like a stamp. Chops were, and still are, used to "sign" official documents, literary works, and agreements, in lieu of a signature with a brush or pen.

Monograms aren't just for the individual. In fact, these concise creations have become hallmarks of global brands. From technology companies like IBM to luxury clothiers like Louis Vuitton, corporate monograms say, "We made this," "We support this," and "This is ours." If we, as consumers, choose to use or wear these brands, we do so as if to say something about ourselves or our status, just like the Victorians.

→ Personal monograms are a visual representation of yourself. Feels like a lot of pressure, huh? Here's where practice comes in handy. Before you make a monogram for

yourself, using your own initials, use the chart to the right to pick an arbitrary letter pair. That's right. Close your eyes and draw a dot somewhere on the chart to the right. Whichever square your mark falls within will be the two letters you'll combine to make a monogram. Working first with a random pair of letters will help you to see the basic forms of each letter and how they might combine visually, without the personal attachment. This purely form-based approach will take off some of the pressure to make the perfect mark for yourself.

What makes the monogram? Try a few of these techniques:

— Overlapping and intersecting lines

— Nesting (putting one letter inside another): letters with counters are ideal for this, like *O* and *A*. Learn more about nesting on page 146.

— Scale: Are you going to use two or three large letters? Two small, one large? One big, one small? Notice how a change in size signals a change in importance.

— Symmetry and asymmetry: some letters are inherently symmetrical, like *M*, *W*, and *H*. How can you explore different alignments of both symmetrical and asymmetrical letters?

← ← →
Zrinka Buljubašić

This chart works ideally with letter pairs, but many monograms have three letters. How might you add an additional letter to the mix?

	A	B	C	D	E	F	G	H	I	J	K	L	M	N	O	P	Q	R	S	T	U	V	W	X	Y	Z
A																										
B																										
C																										
D																										
E																										
F																										
G																										
H																										
I																										
J																										
K																										
L																										
M																										
N																										
O																										
P																										
Q																										
R																										
S																										
T																										
U																										
V																										
W																										
X																										
Y																										
Z																										

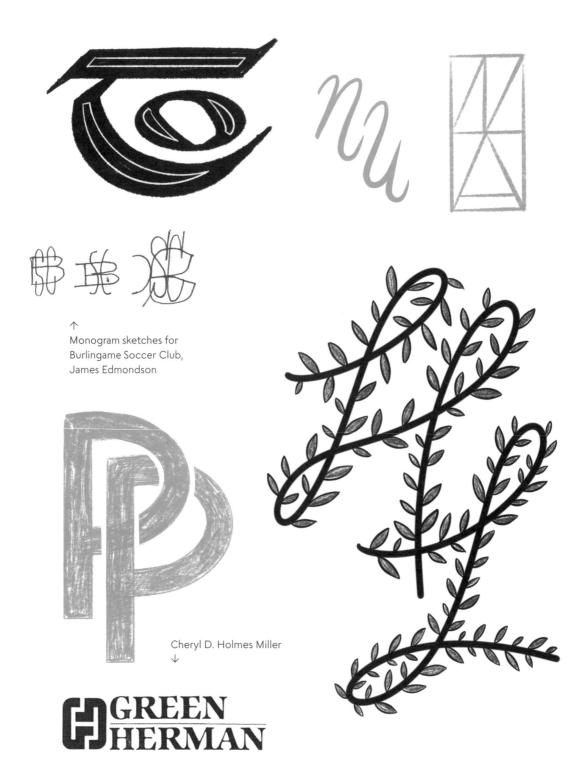

↑
Monogram sketches for
Burlingame Soccer Club,
James Edmondson

Cheryl D. Holmes Miller
↓

Get Ornamental

In his 1931 essay "An Essay on Typography," typographer Eric Gill wrote, "As there is a norm of letterform—the bare body, so to say, of letters—there is also a norm of letter clothes."

To be sure, there are certain norms and conventions that our letters follow—like an uppercase A consisting of two slanted lines and one horizontal line connecting them—but there is so much possibility for an added layer of "clothing" to contribute interest or intrigue.

Gill, so it would seem, is a purist. To him, and many designers like him, the minimalism of a singular, unadorned letterform is a thing of beauty. But this book champions not just the simple but also the weird and even ugly letters.

Designer and researcher Marta Bernstein is one of the world's biggest fans of ugly letters. She's dedicated much of her recent research toward "ugly" nineteenth-century Italian typography.

After the death of the famed neoclassical typographer Giambattista Bodoni in 1813, designers, letterers, and type foundries began to reject the clean, high-contrast letterforms for which Bodoni was known. These designers began to decorate on top of the basic shapes of letters. From flowers to spurs to shading to zigzags, these designers were "trying to catch the spirit of the time….That must have been a really fun time to be alive," says Bernstein.

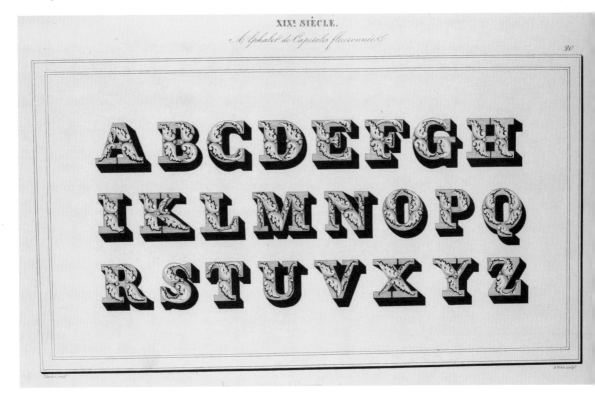

↑
Alphabet Album
Joseph-Balthazar Sylvestre, 1843

Toward the turn of the twentieth century, letterforms began to appear more and more distorted. Instead of applying decoration on top of conventional letter shapes, typographers began to transform the shapes of the letters themselves into some really extraordinary stuff! Many examples of work from this time, coming out of Europe, look as if they could have been made yesterday.

→ For this exercise, adopt either a mid-1800s or a late 1800s model: either decorate on top of an existing letter shape or invent your own highly ornamented letter. Start with just one letter and spend some time on that letter. Go over the top! Get ornamental!

→
The Model Book of Calligraphy, Joris Hoefnagel, 1561–96

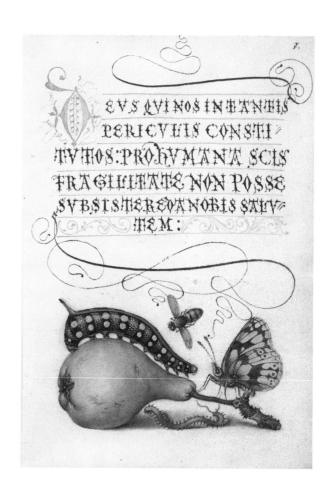

Looking for inspiration? Look to yourself! There are loads of beautiful images of embellished typography, so much so that it can result in visual overload. But fear not—a little introspection can generate one-of-a-kind letterforms.

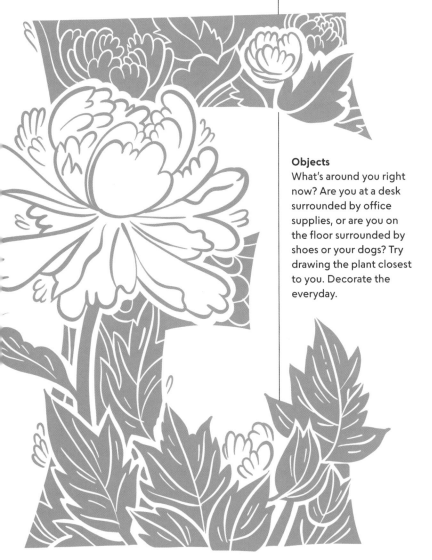

Objects

What's around you right now? Are you at a desk surrounded by office supplies, or are you on the floor surrounded by shoes or your dogs? Try drawing the plant closest to you. Decorate the everyday.

Occasions

Ever get dressed up for an event? Letters can do the same! Often, momentous occasions in our lives are punctuated by ornate, official documents, invitations, or custom cards. Do you or someone you know have an occasion coming up? What about lace-covered letters for a wedding or quinceañera? Why not letter something for your special moments?

Holidays

OK, holidays are also kinds of occasions. What are some holidays in your community? How do you celebrate? How could you be inspired by imagery associated with that holiday and integrate it into your letter designs?

Places

From your local convenience store to coastal towns to grand museums—what kinds of places are you drawn to?

Foods

Fruits and berries were a common decoration used in nineteenth-century European type. They represent fertility and bounty and celebration. Do you have a favorite food? Why not decorate type with drawings of your favorite foods?

One Letter Ad Nauseam

Composer Maurice Ravel was about to go for a swim when he called a friend over to his piano and played a simple melody with one hand.

"I'm going to try to repeat it a number of times without any development, gradually increasing the orchestra as best I can."

The melody he played was the foundation of his magnum opus, *Bolero*. This fifteen-minute piece of music repeats the same melody over and over and over again with little variations added to each

sequence. Ravel experimented with adding a little more horn here, a little more drum there, all while keeping the same basic melodic structure.

What if we applied the same kind of thinking to the way we draw letterforms? Small nuances such as adjusting contrast or adding ornamentation drastically change the attitude of a letterform.

Another way you might approach repetition is to draw the same letter in totally different ways with

each new creation, as letterer Pavel Ripley does. He dedicates a single page of his sketchbook entirely to a letter of the alphabet and then fills the page with unique iterations.

→ Try both methods. Choose a letter and draw it. Then, draw it again, changing something slightly or changing something drastically. Then, do as Ravel does and repeat, repeat, repeat.

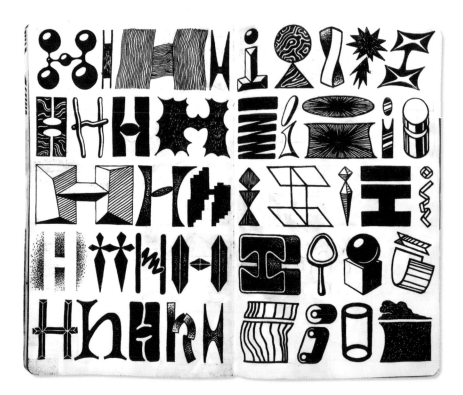

↑
Pavel Ripley

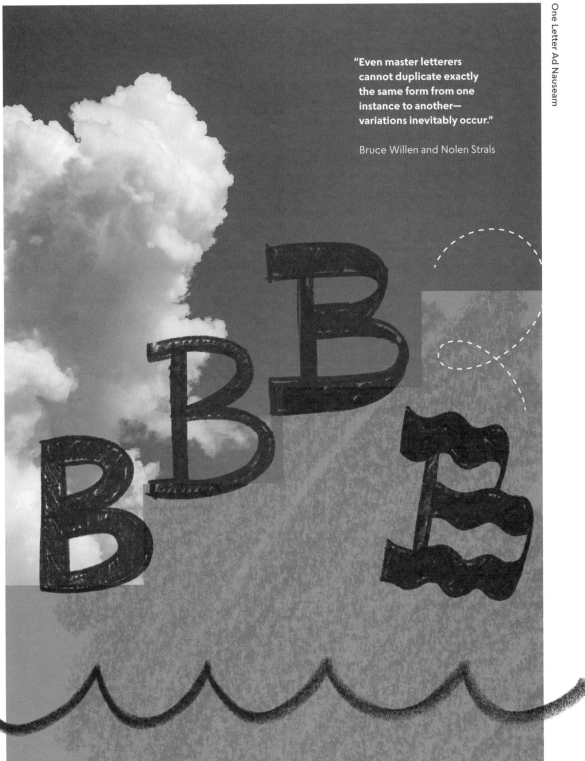

"Even master letterers
cannot duplicate exactly
the same form from one
instance to another—
variations inevitably occur."

Bruce Willen and Nolen Strals

Eggs, Three Ways

This exercise is far from hard (boiled). In fact, it's quite (over) easy!

In the cooking world, there's a term for preparing one ingredient or meal using three different techniques: *three ways*. Canned fish three ways; broccoli three ways; eggs three ways.

This preparation is meant to show an ingredient's versatility—and eggs are just about as versatile as food gets!

→ Letters can play the same game. Working within the constraint of threes, start by lettering a word and then repeat it, each time rendering it a new way. Try using tracing paper for each iteration—that way, you can layer your lettering.

Some of your experiments may look a bit scrambled, but you might discover some new and surprising ways of making letters.

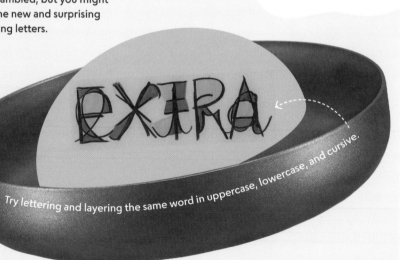

Try lettering and layering the same word in uppercase, lowercase, and cursive.

Same Letter, Different Tool

"Variety's the very spice of life, / That gives it all its flavour."

So says English poet William Cowper in his anthology *The Task and Other Poems*. Cowper wrote these words in 1785, and the same statement is true today!

Why not introduce a little difference, a little variety, into your letterforms? Changing tools mid-letter can add enthusiasm, tension, and spunk to your lettering.

Vive la différence!

→ Gather up as many mark-making tools as you can find. Line them all up on your table, floor, or countertop. Starting with the leftmost tool, make a mark on the page. It can be a line, a squiggle, a smudge—you name it. When you've made your mark, place that tool at the end of the line, all the way to the right. Assess the mark on the page. What letter can you make out of it? Grab the next tool and complete your letter. Continue this method of mark making, tool cycling, and letter making until you've either made a word or used all your lettering tools.

Make It for Media

We live in a world of acronyms: LOL, FYI, ASAP. They operate as a linguistic shorthand for quick messages that use a minimal number of characters.

In the early twentieth century, acronyms were useful tools in the emergent media forms of radio and, later, television. Each radio station was assigned a "call number" so listeners could dial in to a specific station, like WNYC or KUTX. In the United States, stations started with either *K* or *W*, followed by a three-letter station identifier. Television stations operate in much the same way, using either a three- or four-letter acronym to represent the network.

As television graphics became more sophisticated, these acronyms became tools for branding, and graphic designers were called upon to visualize them. These acronyms would appear in bright colors and flashy animations.

→ What is the acronym of your local radio or television station? Chances are they have a logo. Can you redesign it? Can you identify a similarity in the form of the letters? Are there areas where letterforms might connect or overlap?

For more exercises exploring how letters overlap and intersect, check out page 146 and 147.

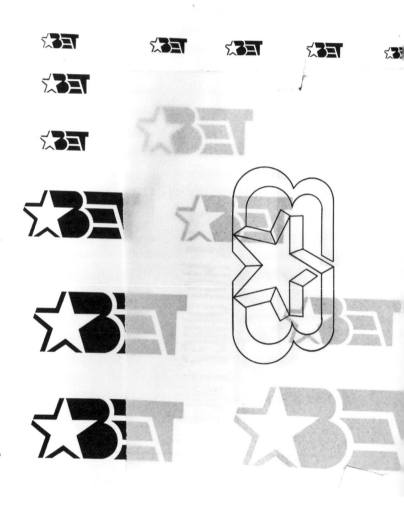

↑
Original sketches for BET,
Black Entertainment Television
Cheryl D. Holmes Miller

Award-winning designer and historian Cheryl D. Holmes Miller shared in a conversation how she became interested in designing for television, providing insight into processes in a time before digital tools.

"The 1950s era of the new media television influenced my interest in what would become today's iconic logos; I wanted to design logos too. The logo mounted upon our family's new color television, the 1961 Motorola logo rebrand, was designed by Black designer Thomas Miller, Morton Goldsholl Associates, Chicago; this was my first introduction to logos. Broadcast television logos of the era led my inspiration: the 1955 CBS logo by William Golden with Georg Olden, a Black art director, New York; ABC, Paul Rand, 1962, New York; PBS, Herb Lubalin, 1971, New York; THIRTEEN, Herb Lubalin, 1979, New York; NBC, Chermayeff & Geismar, 1986, New York; CNN, Anthony Guy Bost, 1980, Atlanta; and Univison, Chermayeff & Geismar, 1990, New York. Thus, my contributions to Black broadcast network television, media communications, and production companies' logo designs: BET-

Black Enterprise Network, 1974 & 1986, Washington, DC; WHMM-TV 32, Howard University, PBS TV, 1982, Washington, DC; WCQR-TV 50 Cable TV, 1982, Washington, DC; In The Public Eye, public relations and communications, 1989, Washington, DC; Rafiki Productions, Inc., TV video production, 1980, Washington, DC.

Each began with a hand sketch; then, with a parchment overlay, an ink rendering was made by hand with curvature rulers and circle, as well as ellipse templates and original Rapidograph pens, Speedball pointed pens, and a variety of drafting and inking instruments and beveled ˙ rules. Cleaning edges with a white corrective gouache-like touch-up paint was the next step. Alternating photo stats, back and forth, of black positives to white reverse/knock-out photostats allowed fine-tuning to yield sharp, clean edges. The final 'stat' was camera ready and delivered to client."

Parts of a Whole

One by one, piece by piece, penny by penny, googly eye by googly eye. This exercise focuses, quite literally, on the built-up letter.

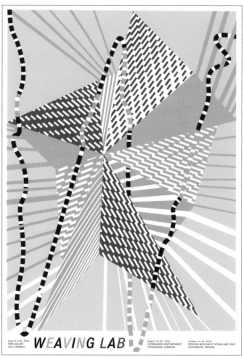

↑
Annik Troxler

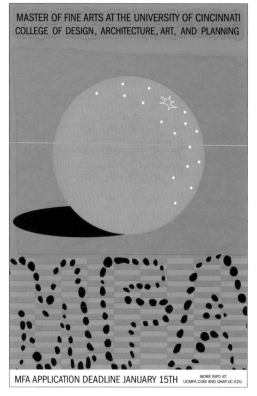

↑
Cryptogram Ink

In this case, the whole LETTER is greater than the sum of its parts.

→ What do you collect? Is there an object or item that you have a lot of? Gather those items in one spot— ideally on a flat work surface, like the floor. Start to push and pull these elements together.

Even if it's not from a collection, you can still gather a lot of something. Sugar, grass clippings, or water droplets would work just fine!

Don't have any physical objects? Grab your pencil or pen and start making repetitive marks on the page. This *M* is made from tiny, scale-like circles, drawn one after another.

→
*Casualties &
Casual Tees*
Kelsey Elder,
Kelsey Dusenka, and
Johannah Herr

Negative Attitude

Typographers would argue that
white space, or negative space,
is just as essential to any letterform
as the positive space.

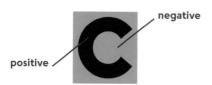

Like the air around us and the
forces of gravity, the negative
space around a letterform pushes
in on its contours. The positive and
negative work together, in tandem,
to form the contour of each letter.
What's unseen and inactive is just as
important as what's seen and active.

Later, in the "Distort" section of
this book (page 127), we'll play with
weird and wonderful counters of
letters. Counters are the negative
spaces within letterforms like an
o. But the term *negative space*
also applies to what's around the
outside of the letter—left, right,
above, below.

→ In this exercise, shift your
approach and start crafting a letter
by the negative space around it.
How does the negative space push
or pull on the letter? You can begin
with pen and paper, but what other
tools or media might you use? Cut
magazines? Wax? Dirty laundry?
Think positive, try the negative!

↑
Shannon Levin

↑
Cyrus Highsmith

Explore type as image. Imagine letters as objects, even people! Discover letters in unlikely places.

3

depict

The Word Picture

Long ago, type and image used to be the same thing.

Some of the world's oldest written languages, such as Egyptian hieroglyphics, began as small drawings. These drawings could signify literal or figurative concepts. For example, the drawing of a sun might represent the sun itself, or it might translate to something more complicated like "warmth" or "giving life" or "god."

As language and communication systems evolved, type and image became separate things. Typography began to be understood as more visually simplified and repeatable, whereas images remained pictorial expressions of the physical world.

This is especially evident in Chinese and Japanese calligraphy. At right, you can see how the image of a tree has, over time, been simplified and refined into the current-day character representing "tree."

Our own Latin alphabet, too, has its roots in the Phoenician and Greek way of writing. The letter A, for example, appears to have originated from a pictogram of an ox. The Phoenicians and Greeks adapted this original form as a more simplified triangle. Can you see how our current-day A resembles the letters in these ancient writing systems?

→ Let's reverse engineer this. Transform one current-day letter into an image.

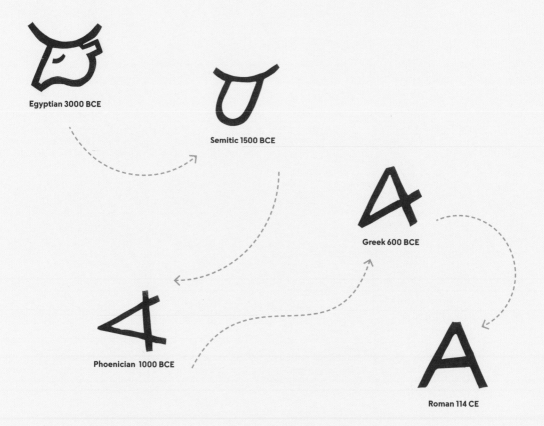

Egyptian 3000 BCE

Semitic 1500 BCE

Greek 600 BCE

Phoenician 1000 BCE

Roman 114 CE

→ What happens when you letter a word in the shape of something else? How do the layers of meaning and form intersect to create an interesting idea?

←
Paula Scher

→ When you see the word *dog*, you conjure an image of a furry animal that barks. But what if you could draw the letters *d-o-g* in the shape of a dog? Does that add an extra layer of meaning or emphasize its dogginess? Try your hand at lettering words that depict the word itself.

Integrating Images

Type and image: the two fundamentals of visual communication.

Even though this book is type- and lettering-focused, you may very well have an interest in incorporating illustrations or photographs into your work.

Typography can support or contradict the intended message of an image. Conversely, images can discredit or enhance typography.

To break this down further, you can consider the degree to which you combine type and image on a spectrum of separation and synthesis. Use the diagram on the opposite page as you create the exercise.

→ Select or create your own image: it may be a photograph, an illustration, a painting—you name it! Then, come up with two words: one that supports or agrees with the image and one that contradicts it. While creating both of these pieces of lettering, be sure to keep in mind the concepts of separation and synthesis. Do either of these extremes enhance your message?

↑↑ ↑
Dingding Hu Zofia Klajs

Separation

Separation, in this context, means that type and image are acting independently from each other. You might choose to place the type and image far apart from each other on the page, you might layer or superimpose, or you might create distinct areas in your composition that are type-only or image-only.

Synthesis

Synthesis implies that type and image are compositionally or contextually working together toward the same goal. You might choose to put type and image on a shared surface; you might consider using optical effects—like perspective drawing or motion—to make the type feel like it belongs with the image.

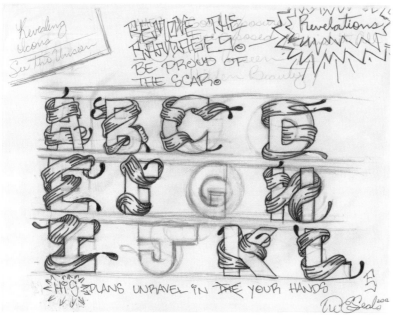

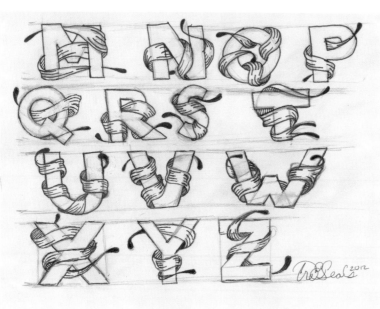

Type designer Tré Seals began his type design journey in high school. He created these sketches for what would become the font Unveil.

Notice how Seals interweaves the image of a ribbon through each letter—type and image united!

←
Tré Seals

→
Aratus,
Aratea, ninth century

Each page of the *Aratea* has an illustration of a constellation on the top half of the page and a corresponding poem on the bottom. Here, Canis Minor is shown, imaginatively rampant in the night sky. Can you see the stars indicated by those red dots?

The text that makes up the body of the constellations comes from Hyginus's *Astronomica*. "The passages used to form the images describe the constellation… in this way they become tied to one another: neither the words nor images would make full sense without the other there to complete the scene."

DIY Letter Stamps

To Dutch design legend Karel Martens, any object with a surface can be coated with ink and printed. Martens is famous for applying ink to any number of objects: metal, foam, toys, housewares, and tools. Anything is fair game.

This exercise challenges you to create letterforms by either creating your own stamps or using found objects as stamps.

But where do you start?

→ Start with an eraser.

Any size or shape of eraser will do. If you can't get your hands on an eraser, find a material that has similar properties: firm enough to hold its shape but soft enough to cut into. Look at your eraser. What shape is it? What letters will fit nicely within that shape? Draw your letter with a pencil, grab a craft blade, and start carving away any material that's not part of your letterform.

Remember that when you're carving any kind of stamp, whatever you print on the paper will be mirrored. That means if you're carving a letter, carve it backward.

Once you've got your letter carved, it's time to ink and print! You're welcome to use printmaking inks if you have them, but any ink stamp pad will do. You can even print with acrylic paint—but watch out, that stuff dries fast.

↑
Cyrus Highsmith

Letters Locomote

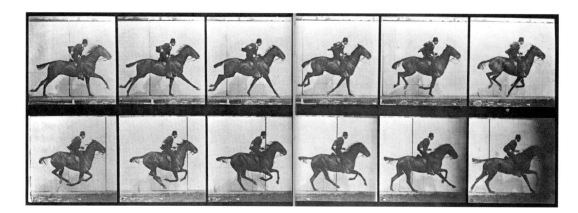

For millennia, humans have depicted objects in motion. From Paleolithic cave paintings to action-packed works of the Renaissance masters, these images feature subjects frozen in time, stuck in a still frame of anticipated motion.

In the late 1800s, photographer Eadweard Muybridge was able to capture images of animals and people in motion. His most notable photographic discovery proved that the four hooves of a horse leave the ground in full gallop.

Thanks to Muybridge's work, we are able to see individual frames, unique states of a subject's motion.

One of the most iconic examples of motion represented in a static medium is Marcel Duchamp's *Nude Descending a Staircase, No. 2.* Duchamp depicts the same figure in multiple views, with repeating lines and shapes to show its descent down the canvas.

"Somewhere between the Futurists' dynamic movement and Duchamp's diagrammatic concept of movement lies comic's motion line," says author and comic artist Scott McCloud. These **motion lines**, aka "zip ribbons," represent the linear path of an object as it travels through space. Our eyes follow these lines, tracking the "movement" of objects and perceiving their actions from one state of motion to another.

When planning an animation, artists will create a storyboard to envision what will happen in each frame. Artists will use repeated images and motion lines, as well as frame-by-frame transitions, to depict movement.

→ Start this exercise by selecting a letter and an action, like:

— The letter *k* riding a bicycle
— The letter *M* climbing a mountain
— The letter *j* chopping carrots

Once you've got your letter and action, it's time to visualize that action. Use one of the four techniques—anticipated motion, repeating lines and shapes, motion lines, or frame-by-frame—to show the movement of your letter.

Some things to consider:

— Gravity. If your letter is performing an action on our planet Earth, gravity demands that objects in space will fall downward.

— Weight. Are certain parts of your letter heavier than others? How might thinner or lighter strokes of a letter move differently than heavier strokes?

— Mimicry. Birds move differently than gears. Lizards move differently than umbrellas. Does your letter resemble anything in nature or the built environment? How might you draw inspiration from movements you recognize?

Visual artist Mundoba puts letters into motion with rice, a flat surface, and a quick flick of the wrist.

↑ →
Mundoba

**Start with a prototype.
Kelli Anderson, designer and
author of award-winning
pop-up books, engineers
paper prototypes that make
letters move!**

↓→
Kelli Anderson

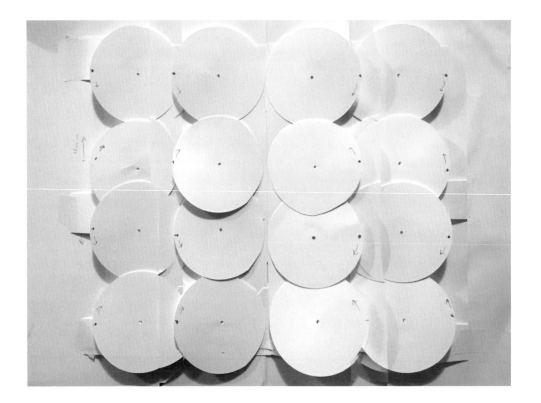

Corporeal Characters

It's human to be self-centered—even the ancient philosopher Ptolemy thought so! He believed that the earth was at the center of the universe. Leonardo da Vinci's famous drawing *The Vitruvian Man* elevates the ideal proportions of a man and how it relates to geometry. Today, various fields of design and architecture practice "human-centered design," which aims to solve our worldly problems through an understanding of the human perspective. We design objects for our own use, for our own scale, and for our own entertainment. We humans even had the audacity to name typographic anatomy after our own bodies! Let's take a literal approach to that idea.

→ Letters as people! People as letters! Create a full character set—or maybe just a word—that transforms each letter into a piece of our own anatomy. Will there be disembodied limbs? Could each letter be formed out of our hands or feet? Are your letters hyperreal or playfully abstracted?

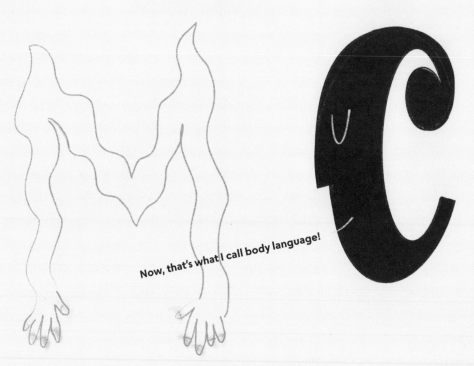

Now, that's what I call body language!

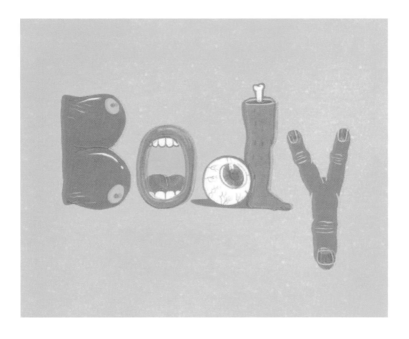

↑
Shannon Levin

↑ →
Cheryl D. Holmes Miller

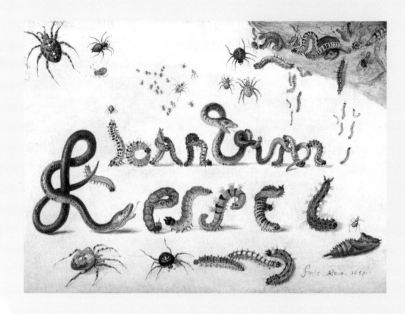

↑
Signature of Caterpillars and Snakes, Jan van Kessel, 1657

Animals and monsters are OK too!

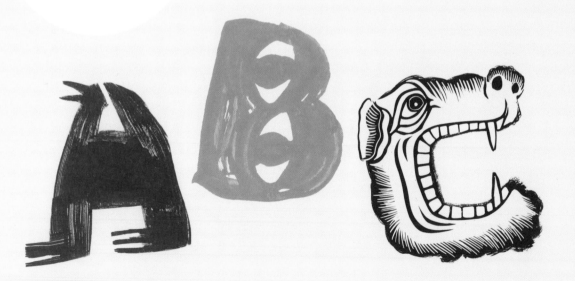

Letters as Leisure

Letters move, shake, and delight! Letters can also calm, support, and relax. The previous exercises asked you to imagine how letters might be animated, how they might walk down a street or land from a fall.

→ In this exercise, you'll imagine how letters might act as objects of relaxation, as furniture.

Could you sit comfortably on an O? Perhaps you can discover an inventive way to lounge on an M.

Consider viewpoints and perspectives. What if a chair appeared typical and unassuming from the side but revealed an enormous Q when viewed from above? Could you fill a room with artfully designed custom letter furniture?

Book Spines

(It's OK to turn this book sideways.)

As we learned from the "Containers as Composition" exercise (see page 64), specific shapes and formats can be both a constraint and a great liberator for the mind.

You'd be hard-pressed to find a format more vertical than the book spine. The spine is the edge of the book where all of its pages are folded, stitched, and bound. Western books have spines located on the left side of the cover, whereas books in Arabic and Japanese, for example, have spines on the right side of the cover.

Unlike the front cover of a book, where designs and content can be broad and expressive, book spines have to be a bit more functional. They are used as a navigational tool in bookstores and libraries to help employees and customers sort and find publications. Designers have to be economical with this space, but that doesn't mean it has to be boring!

→ What's your favorite book? Write down its title, author, and publisher. Then, select a format. Is this book going to be a massive reproduction of Homer's *Odyssey* or a miniature, pocketable version of Jane Austen's *Pride and Prejudice*?

will you go hori zon tal?

Go vertical?

Some books need no introduction

YOUR
BIOGRAPHY

VOL. I

DANTE'S INFERNO

These slender spaces are typically just a few inches wide, if even, and should contain:

The title of the book

The author's name (or, at least, the last name)

The publisher's logo

Human-Centered Lettering?

Spine? Skeleton? Ear? Shoulder? *More* body language? We're human. We can't help but name things after our own anatomy.

Font Face

Human faces are capable of expressing a wide range of emotions. Typography can do the same!

→ In this exercise, we'll use the human face to create an alphabet. First, draw a contour line drawing of yourself or a friend. Second, isolate three shapes in your drawing. Use tracing paper. Third, create one

letterform using those three shapes. Fourth, draw an entire alphabet based on those shapes.

You may find that some letters like a capital *I* could be made from just one shape, whereas a letter like *M* may require multiple shapes. Feel free to reflect, rotate, and repeat shapes.

→
Laura Gonima

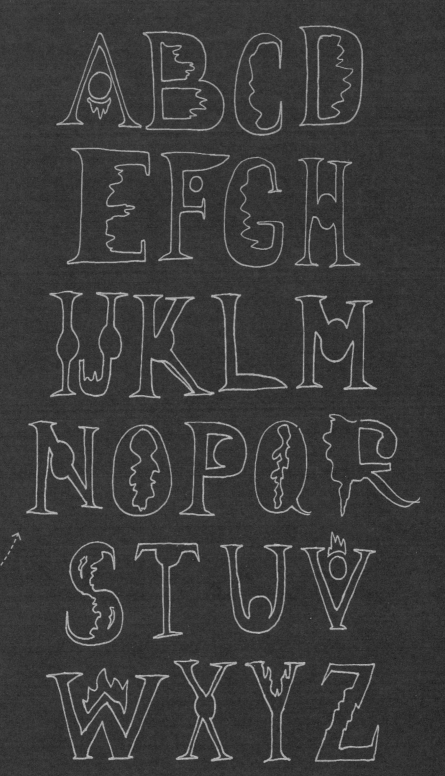

"EYEBALL SERIF"

Letter as Sculpture

1. Pick a word or phrase.

2. Start from the bottom.

3. Stack.

In a conversation with
the designer Ed Fella,
he remarked, "This
rather anthropomorphic
arrangement of the phrase
'This work (this that) serves
no cause' alludes to a figure
holding a torch (4-for) and
a crutch or cane.

It's one of 91 pages in an
8 ½-by-11-inch sketchbook
which explored a kind
of 'deconstruction' of
letterforms and contexts,
fragmented in a variety
of configurations,
sometimes readable and
mostly not quite."

←
Ed Fella

Art-Inspired Alphabet

What would an alphabet by Pablo Picasso look like? Would Henri Matisse's be made of cut paper? Would Jacob Lawrence's be bold and graphic?

Conjure up images of your favorite artist's work or do a quick online search. What do you notice about their work? What do you see? What colors does the artist use? Is their work simple and minimal or complex and highly detailed? Do they work in 2D or 3D?

What is your relationship with this artist and their work? What do you love about the work? Perhaps you can draw on personal experience from seeing the artist's work for the first time. Write or sketch responses to these questions to help frame your designs.

→ First, without using color, sketch out the letters that make up the artist's first name. How might that artist make letterforms? Do you try to mimic their work using their medium of choice? For example: Ruth Asawa wove wire to create undulating, wiggly forms. Would an Asawa-inspired alphabet be made from looped, woven metal?

Once you're satisfied with your test letters, see how that might translate to an entire alphabet.

Pay attention to the details in the artist's work. How might they have used their brush to create a certain shape? Did they use their hands or a sponge to mold clay? Is their work surreal, pushing the boundaries of reality?

Take a look at these two works by painter and muralist Emily Eisenhart. What do you see? How might you build a letter—or even an alphabet—inspired by her works?

→
Emily Eisenhart

Found Forms

At the beginning of this book, we talked about various drawing and painting tools. Included among the usual suspects such as pencils and brush pens are the unconventional materials: tape, string, paper clips.

In the 1990s, designer Paul Elliman created a library of letters with his creation of Found Font. Elliman began developing this font by collecting little human-made objects—things that you and I might call junk. But not Elliman! He saw beauty, surprise, and possibility in these neglected and seemingly useless objects. Found Font "shows the connection between construction of the environment and construction of language." Elliman transformed the ordinary—how might you?

→ Search your environment and find objects that might resemble letterforms. Assemble them in conventional and unconventional ways to create an alphabet. How can you push the limits of letterforms? Will you apply any kind of consistency or rules for your alphabet? Create a twenty-six character alphabet using only photographs of objects found in your environment.

CREATIVITY TAKES COURAGE

↑
Haley Jackson

Try walking around with a **viewfinder** to focus your observation. Find a sheet of paper and cut out a rectangle—or square, or any shape you like—out of the center. This will create a viewing frame, allowing you to see your surroundings in a new light.

Take a walk. Letter what you see.

Cropped Characters

Don't discard that viewfinder! We'll be making use of it—or a camera—to capture letters in unlikely places.

Rob Walker, author of *The Art of Noticing,* calls for his readers "to stay eager, to connect, to find interest in the everyday, to notice what everybody else overlooks." These things, he says, speak to the difference between "accepting what the world presents and noticing what matters to you." As we move through the world, we more or less choose what to pay attention to, what to notice, and what to engage with. Those things that we notice help us in forming a perspective about what we like or dislike, what we're afraid of, and what we delight in.

Ever See the Man in the Moon?

That's pareidolia at work. Pareidolia is a psychological phenomenon where the mind responds to something, usually an image or a sound, and creates a familiar pattern or image where none exists.

Common examples are animals, faces, or objects perceived in cloud formations and the Man in the Moon.

Where passersby may see a crack in the sidewalk, you might see an *X*. Is that corner of a building an *N*?

→ Set aside some time. Grab a camera and go for a walk, wander around your house, visit a park, or ride the subway—whatever you fancy. As you stroll, look through your camera or phone to search for unlikely letters in your environment. Make use of the camera's ability to zoom and crop. Take one photo for each letter of the alphabet.

Is that an *L* in that door handle?

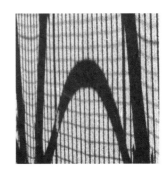

"Every day is filled with opportunities to be amazed, surprised, enthralled—to experience the enchanting everyday."

—Rob Walker

**Push the limits
of legibility!
Discover new ways
of manipulating,
abstracting, and
making letters.**

4

distoRt

Make It Minimal

Spanning art, design, architecture, music, and even lifestyles, minimalism upholds a "less is more" approach.

The arrow on this building is made of no additional materials. Instead, the underlying concrete has been carved out and removed. No extra stuff, no fuss.

The illustration of a bird at right needs no eyes, feet, or wings to communicate its birdness. The addition of the quintessential beak is all we need to make sense of the shapes.

If we remove the counter of an *A*, would we still be able to comprehend its meaning? If we remove ascenders or descenders, then what happens? At what point does an abstracted letter cease to be a letter? How little do we need to communicate? What are the most essential parts of a letter? How can you isolate those essential parts and represent letterforms with limited visuals?

→ Make all twenty-six characters with as few shapes—or strokes— as possible.

the

letter

T

Cut Characters

Within each of us is a rich personality with many traits, likes, dislikes, and habits. You may crave adventure and yet also enjoy the comforts of home. You may like cooked bananas but hate the taste of a raw banana. All of these nuances add up to what makes you uniquely you.

Could letters be the same? We've already established that the shape of letterforms and the tools with which they're created can express emotions, can carry baggage. With thoughtful combinations of forms, you can even create a letter that expresses multiple personalities.

→ There are a few different ways to tackle this one.

Collage: Seek out your own nonprecious magazine clippings, photos, or printed matter. Tear them in pieces (halves?) and paste them together onto a page.

Sticky notes: See how letterer Shannon Levin divided a *g* into four quadrants? Grab some sticky notes, puzzle them in a grid, and draw your letter in different styles. What happens if you rotate some of the tiles?

Materials: Keetra Dean Dixon's piece *Half-Texts* combines multiple materials and even joins two words! The materials speak as much as the words. In your immediate vicinity, what materials might you combine to create a letter or word? Candle wax and ice cubes? Cut paper and rocks?

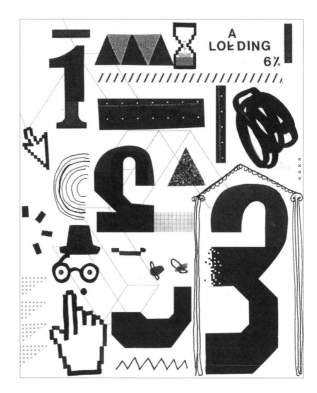

↓
Shannon Levin

↑
Ola Niepsuj

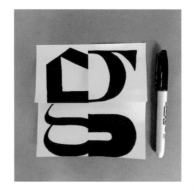

What happens when you use letters from a different language? Try rummaging around for samples in Hebrew, Arabic, or Japanese.

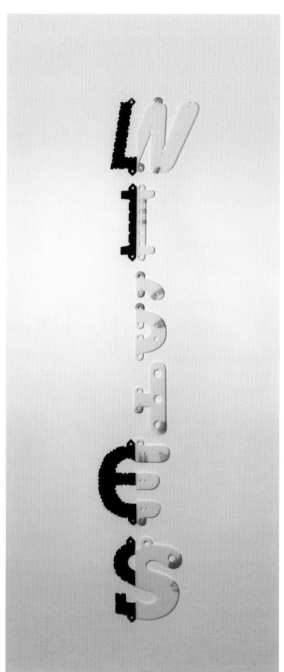

↑
Half-Texts
Keetra Dean Dixon

Collage

The Traditional Art of Cut and Paste

Have you ever made a piece of mixed-media art? How about a mosaic? Have you ever created a mixtape? Burned a CD? Created a playlist? Then, congratulations, you've created a collage!

Collage, as an output and as a creative process, involves a group of disparate objects or elements that are assembled into a whole. Some collages may be abstract expressions, while others might communicate mixed messages, parody, or cultural or social commentary. There's tremendous power and potential in such a simple act of assemblage.

In this exercise, you'll create two kinds of collages: a single-letter composition and a typographic composition.

So, gather up your magazines! Your scraps of paper, old photographs and postcards, newspapers—anything you can take a pair of scissors to.

→ Single-Letter Composition: Create one letter from a series of paper scraps.

→ Typographic Composition: Source ready-made typography from a magazine, newspaper, or any paper ephemera. Cut out these words or letters and combine them to form reanimated messages.

↑
Able Parris

Collage Approaches That Get the Brain Going

Symmetry
Can you find ways to use two visual elements that are symmetrical, as the *M* to the left does?

Big and Small
Essentially, scale by another name. Try changing the scale of your cutouts, patterns, or brush and pen strokes.

Mixing Media
That's right, brush and pen strokes! Collages can combine various media. Try enhancing your paper cutout with conventional—or unconventional—drawing tools.

Topical
What's happening in your world right now? Is there a social or cultural event coming up? How could you make your collages represent that happening?

(New) Meaning
One of the most enjoyable parts of collage is sourcing incongruous images and remixing them. Could that typography from a ketchup advertisement offer new meaning when paired with type from a postcard from Hawaii?

Temporary Typography

Sometimes the most temporary things can be the most beautiful.

Take flowers. They bloom abundantly during the growing season, and then—poof! They disappear as quickly as they arrived. For the rest of the year, when they're not in bloom, we look forward to the next spring. If not for their absence, we wouldn't be able to appreciate flowers' transient beauty. Grass grows. Orange peels rot. Metal rusts.

How can we apply this same kind of thinking to typography?

In this exercise, you're tasked with exploring materials and the forces that alter them over time.

→ Find a material you'd like to work with. What are the essential properties of this material? Does it melt when heat is applied? Does it squish when you step on it? Create a letter with this material and then subject it to the elements.

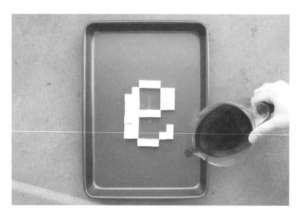

Sugar cubes and coffee? Sounds like a recipe for some creative lettering!

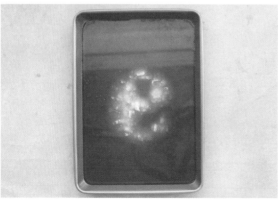

Kelcey Gray

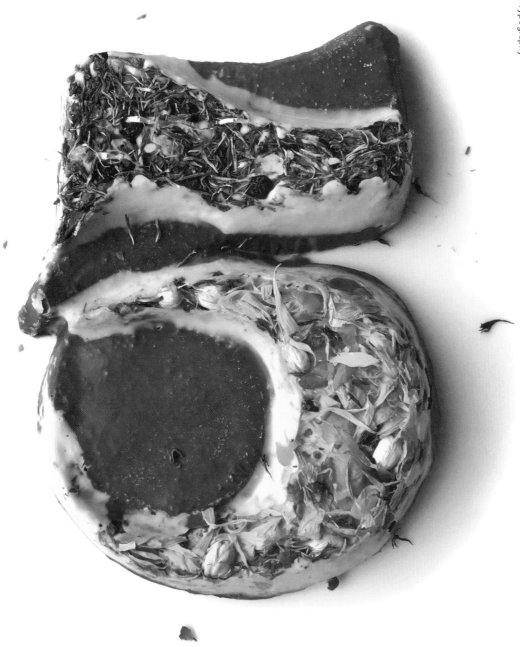

↑
Zrinka Buljubašić

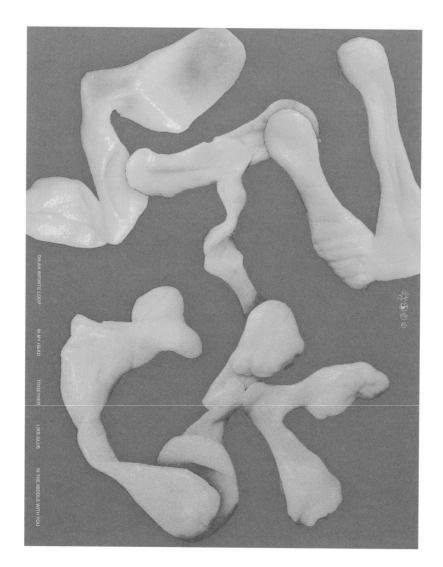

↑
Ben Zerbo

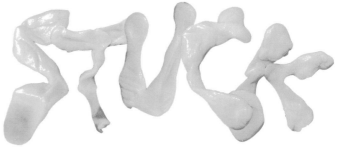

Strange En-counters

"The letter is two shapes, one light, one dark. I call the light shape the white of the letter and the dark shape the black."

That dark shape, as typographer Gerrit Noordzij suggests, is the letterform itself, while the white part is the negative space—the space within and around a letterform.

We now know that the enclosed, negative spaces within letterforms are called "counters." (Flip back to page 94 if you don't remember.) Counters typically take on rounded and geometric shapes, but their proportions and relationship to the "black" of the letter can vary widely.

These two *B*'s, for example, have different strokes and shapes, and so, too, do their counterforms.

The example uses quite traditional letterforms, but contemporary letterers are challenging that norm by designing odd and unconventional counterforms.

→ How might you incorporate unconventional counters to add visual interest and meaning to your letters?

↑
Cryptogram Ink

Counters and apertures help us differentiate one letter from one another. Without them, a lowercase *u* could be difficult to distinguish from a lowercase *n*. But we wouldn't be very adventurous letterers if we didn't explore the possibilities!

→ Try redrawing a previous piece of lettering without any counters. What happens to legibility?

↑
Annette Hui

Sara Osterhouse

Don't
forget
to

Scrawl, Fold, Stretch

FIRST Begin with two vertical strips of paper. Fold them into four panels accordion style, like this:

SECOND Letter a word that spans the height of the folded seam, on panels 1 and 4. When you unfold it, it should look something like this:

THIRD Fold the top and bottom portions backward and connect the two letters however you like. Try curves, squiggles, loops, patterns—you name it!

When you're finished, unfold the sheet to see your work. Thanks to the folds, the letterforms will appear wildly stretched!

Try this one with a friend!

← ↑
Happening Studio

A simple, meditative act of paper folding
became the springboard for designing this
wrapping paper. A letterform can be achieved
by folding perforated lines and casting
shadows. The letter *W* is an iconic part of
the Whitney's bold identity, designed by
Experimental Jetset.

Half 'n' Half

Grab a sheet of paper and fold it in four equal vertical panels. Fold the outer panels inward toward the center fold, as shown at left.

Select a single letter. Draw the left half of that letter on the outer left panel—panel 1 in the example. Draw the right half of the letter on panel 2 in a different style or medium.

Next, unfold panel 2, exposing panel 4, and draw a different interpretation of the right side of the letter. Go nuts—you've got so much space to play! Now, fold down panel 2, open panel 1, and draw the left half of the letter on panel 3.

Once you've finished your halves, fold and unfold the pages to see how the different sides of the letter complement—or contrast with—each other. What happens when your letters meet? Do they line up? Which combinations work better together?

Seeking ʏɹɈəɯɯʎƧ

Some letters in the Roman alphabet are symmetrical. *A*'s, *M*'s, and *O*'s all have vertical lines of symmetry, while *H*'s, *B*'s, and *C*'s have horizontal lines of symmetry. Let's take advantage of this visual balance!

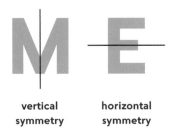

vertical symmetry **horizontal symmetry**

→ Fold a piece of paper in half, vertically or horizontally, creating a seam down the middle of the page. Open up the folded paper and lay it flat. Select one of the alphabet's symmetrical letters and, using a wet medium, create half of the letter on the left side of the page. Acrylic paint works great for this. Before it dries, fold the paper closed. Open up the paper. The results might surprise you!

→ Many contemporary brands use symmetrical monograms for their logos. Instead of drawing half a letter, try modifying this technique by drawing a full letter on the left side, then folding it. You might create the next hit branded monogram!

→ What are other ingenious ways of making symmetrical letterforms? How might you make use of reflective surfaces like mirrors or water?

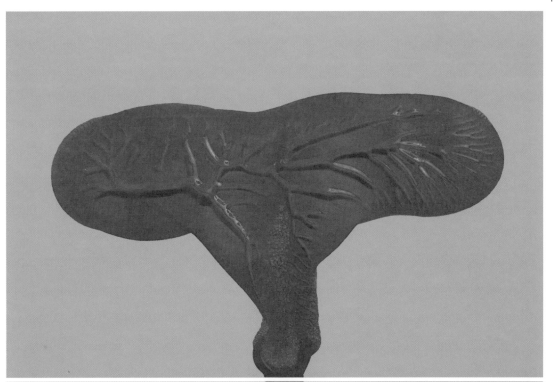

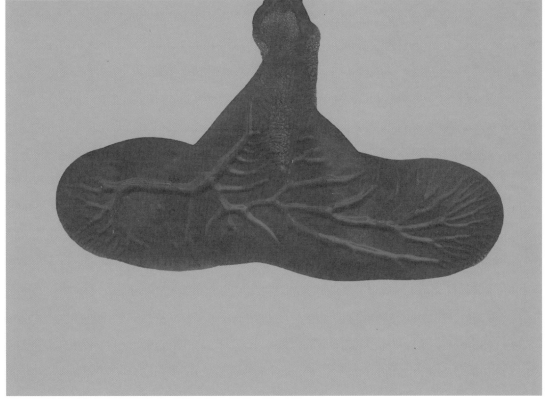

Ligatures and Nesting

Ligatures are the combination of two or more letters, or glyphs, into a single glyph or symbol.

These character combos have been around nearly as long as written communication. From the earliest known script, Sumerian cuneiform, to the work of medieval scribes to the digital typefaces of the present day, ligatures have been an efficient shorthand for times when communication needed to be quick and space efficient!

Ligatures are most often talked about in the context of movable type, aka letterpress. In printing with movable type, each letter was a discrete little block of wood or metal. Each one of these blocks was, often, just a bit wider and taller than the letter. These blocks could get only so close to one another! Hence the need for ligatures. Foundries and punch cutters—people who cut out the letters—created single blocks for common letter pairs. Ligatures are still commonly used in today's typefaces and even in handwriting! Whether it's consciously done or not, are there any letters in your handwriting that you combine into ligatures?

Nesting, or interlocking, is the technique of placing letters in such close proximity that one character is tucked under, above, or within

another. Take, for example, the capital letter *L*. There's a lot of white space in the top right area of that letter!

Nesting takes advantage of the negative space around a letter, allowing letterers and designers to maximize the space each letter occupies on the page. Not only does nesting economize space, it also allows for some surprising and playful character combinations!

→ Practice drawing some common ligatures: *ff, fl, fi, Th, ffl*. Once you've gotten comfortable with your new character combos, letter full words that use your ligature, like waffle, final, Thick, or puffy. Does it feel natural to combine these letters? How does it affect the legibility of your lettering?

Did you know that some symbols started as a ligature? The modern-day ampersand can trace its roots back to a ligature combining *e* and *t*, or *et*, the Latin word for "and." Do you see the *e* and *t* in the example above?

The creation of the *fl* ligature allowed these two letters to sit much closer together.

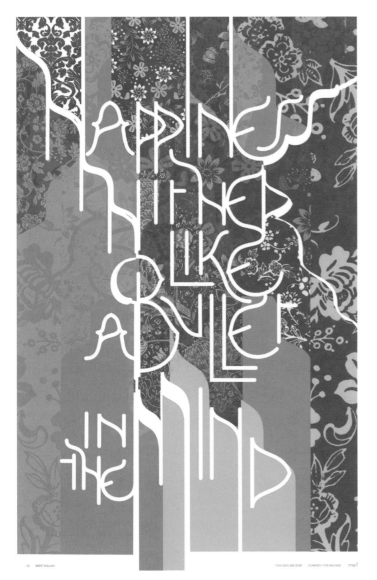

↑
Ian Lynam

→ Which letters can you identify for opportunities to interlock? Scribble down a few possibilities. After you've identified a few good letter pairs—like the *LE* on the opposite page—see if you can conjure up words that conceptually align with nesting and interlocking. How about *machine* or *vault* or *basket*? Whatever your word, nest those letters!

Make Your Own Modules

As we learned from the "Make It Modular" exercise (see page 56), the alphabet can be created from a repeatable system of shapes.

That exercise prompted you to use pen and paper to craft modules, but what if you made those modules out of something else? Felt? Feathers? French fries?

Italian designer Bruno Munari, well known for his playful approach to design, created a boxed set of foam shapes called ABC with Imagination. Soft and kid-friendly, the foam lines and curves could be placed in near-endless combinations.

→ Create your own modules out of your chosen material. Don't be afraid to think big! Test the efficacy of your modules by piecing them together to form letters, words, or pictures. Once you're satisfied, hand your modules to a friend or family member. What do they make?

Can you gamify it?

To gamify something means to transform an activity or process into something like a game. What might be the end goal? What are the means by which participants might meet that goal? Is it competitive? Who can make the word *peanut* the fastest? Maybe it's single-player, with the participant limited to using no more than fifteen of your modules.

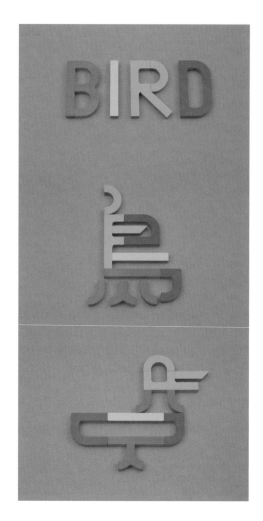

↑
Toypography
Dainippon Type Organization

Disconnect Reconnect

This one's cathartic.

→ First, find a piece of paper, large
or small. Now, break that paper into
sections—use your hands to tear or
scissors or a craft knife to cut. Don't
overthink it.

Letter a different word on each
fragment. Then, piece all of them
together again. How does it
look? How did the edges of the
torn or cut paper affect the way
you lettered? Did you fill each
fragment?

s

h

s

h

i

p

a

e

f

t

What happens if you create illustrations or patterns before cutting out the shapes?

Stencils

Stencils can be defined as any intermediary material with cut-out shapes where paint, pigment, or ink is pushed through the voids to create an image on the surface beneath.

Although we now commonly see stencils made from plastic and metal, stenciling is one of the oldest ways of making images. Perhaps the earliest known example of humans using stencils can be found in the Cueva de las Manos in Argentina. Archaeologists think that cave dwellers placed their hands against the rock surface and used reeds filled with pigment to blow paint onto the surface of the rock. Just like modern-day spray paint!

Jump ahead to the twentieth century. In Western post-industrialized society, stencils became useful manufacturing tools, as a means of efficiently and inexpensively duplicating letters and images. If you're a manufacturer of light bulbs and you need to ship them across the country, a stencil that says "fragile" allows your employees to quickly, clearly, and consistently label each box. Stenciling also became an inexpensive way to create templates for signage. Some city services still use stencils for public signage today. No need for costly materials—all you need is a stencil and some paint.

The efficiency of stencils is invaluable in drafting and planning. Before digital rendering tools, architects and drafters would use typographic and shape stencils to create and standardize drawings of buildings and landscapes.

Stencils can be made out of almost anything you can cut a hole into. That means that you, your mom, your cousin—anyone—can grab a sheet of paper, cut away some shapes, grab some paint, and start stenciling. This accessibility has captured the attention of communities and subcultures around the world—from punk musicians to advocacy groups, graffiti writers to latte artists.

Stencils operate on two extremes of the design spectrum: efficiency and play.

→ Do you have a message to share with the world? Or do you want to put your name on all your art supplies? Whether your motivation is social or personal, search within yourself to find a message you want to stencil. Remember: stencils are ideal for repeatable messages, so don't be afraid to think quantity! Use the materials you have at your disposal. A thick paper like card stock can work well. Letter your message onto the paper, just like you usually would, but don't forget to add bridges (see right). Then, cut!

After you've cut out your stencil letters, it's time to choose a medium to pass through the stencil. Spray paint is a classic choice. You may opt for a different kind of paint, like acrylic, or even a powdery substance like flour or sugar. If you're working outside on a windy day, you may need to tape your stencil to your surface.

The world is your canvas. Get stenciling!

Don't Forget to Build Bridges

bridge

A bridge is that little piece of material that connects the negative space around the letter to the counter space. Without it, your counters will fall right out of your letters!

Determine Distance: A Note on Spray Paint

Once you've got your stencil made and ready for paint, consider what kind of finish you're looking for. If you want crisp, clean letters, be sure to hold your stencil close to the final surface. If you want diffused and fuzzy shapes, increase the distance between your stencil and the final surface.

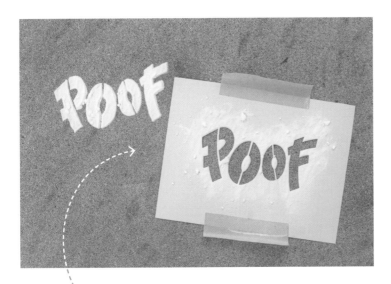

This stencil is made with paper and baking soda on concrete. Powdery, more temporary materials are a great way to test your stencil before using more permanent mediums like spray paint.

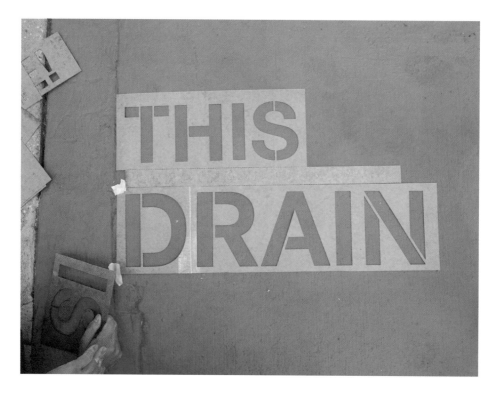

↑ →
A team of Maryland Institute College of Art (MICA) students collaborated with the Greenmount West Community Association to find creative ways to reduce stormwater pollution through community-based educational endeavors. Solutions included painted storm drains, community events, easily reproducible educational materials, and play-based learning tools.

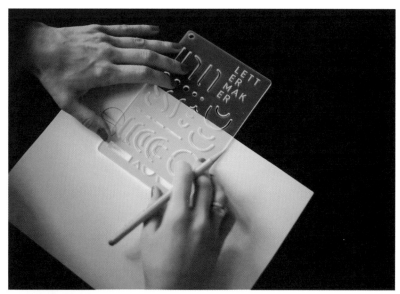

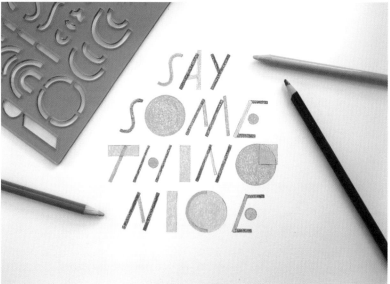

↑
LetterMaker stencil
Kelcey Gray

Letters and Light

This exercise exists somewhere between the realms of stencil, craft, performance, experience, and film.

As in the stencil exercise, you can use scissors or a craft knife to cut letters out of paper and shine a light through them. Then you're done—right? There's much more to be explored here. Whatever you letter, use the following variations to explore the potential of lettering and light.

As you letter with light, consider the following:

Consider grabbing a camera to capture your lit creations.

Material

Paper is great for quick prototypes, but what other materials interact with light? Translucent or transparent materials like colored acrylics could add another dimension to your work: light, shadow, and color!

→
James Walker

Light Source
Where will your light come from? Is it natural, like sunlight, or unnatural, like LED or projected light? Will your light source move in relation to your stencil?

Space
Where will this lettering experience take place? A dark room? At night in the backyard? Midday in summer? The setting in which you perform this exercise may affect time and movement.

Surface
What object will receive your lighted lettering? Will your work be displayed on the pavement? On clothing? Against a wall? Surface and space go hand in hand.

Time and Movement
If your light source moves, how does that movement change how your work feels over time? Will the light flicker or glow? Will it rise and fall like the sun?

What does it say versus what is it saying? Investigate how the way you letter enhances or detracts from your message.

5

dictate

Word Play

There is so much graphic potential in letterforms.

That's what Robert Brownjohn thought! In 1959 Brownjohn produced a handmade book called *Watching Words Move*. Within its pages are cut-and-pasted letters set in black and white. Each word, be it a noun, verb, or adjective, was turned into a bespoke pictorial composition—an action. As the title of the book suggests, we're asked not just to read the words but to watch the words.

Three years later, in 1962, Brownjohn, along with business partners Ivan Chermayeff and Tom Geismar, published the book under its original title with a bright yellow cover. Since then, the book has become a staple in design education to showcase typography's capacity for visual communication.

→ Instead of watching words move, can you *make* words move?

↑ →
Workshop at Central Elementary
School in Riverside, Illinois
Tanner Woodford

addding cnahge radnom stripe

ba‾ance ddoouubbllee shape s–btract

ball°°n dr p shred tight

bottom si y thr °w
bottom

b ° ° m h·dden s lo pp y upstairs

breaking m·ss·ng squiggle zig-zag
breaking

Parody and Play

→ Think of a word or phrase
and then create a piece of
lettering expressing your own
definition of that word—e.g.,
"photograph: a way to remember
things we forget."

DOOF DOOF

Ian Lynam loves words. As a designer and writer, he often has reason to consider language and typography (which we've already established as the visual component of text). Ian travels the globe conducting design and writing exercises to stir the brains of attendees and to spark inspiration through language.

One of the workshops he conducts is called DOOF DOOF. Why?

> "'Doof Doof,' if you are unfamiliar, is Australian slang for techno music.
>
> (This workshop had nothing to do with techno music. I just love the sound of that term.)
>
> Doof Doof is a vernacular neologism, a localized piece of newly created verbal/visual language that has a specific application. It is a word that was somehow summoned out of the ether to describe something that already had a name."

In this workshop, Lynam encourages participants to begin writing by drawing connections between things that are timeless—such as beauty, conflict, and health—and things that are timely—current trends, memes, or popular news stories. According to Lynam, pairing the timeless with the timely, and then inserting yourself and your own perspective, adds value and depth to your work.

→ What happens when you combine the classics with the contemporary? Draw a single letter that combines a timeless visual with a timely visual.

Double Meaning

→Combine two words or ideas into a single piece of lettering.

Use the concept of unity or of conflict to focus your designs.

Unity

Two ideas acting together as one, reinforcing each other. These ideas may be two different words that mean the same thing (synonyms), two parts of a whole, or maybe even two similar-sounding words that are spelled differently (homonyms).

— nine and 9
— tree and green
— hot and summer
— cup and saucer
— kick and soccer ball

Conflict

Two ideas in opposition create tension; they're contradictory. But by placing them together in a single piece of lettering, we emphasize their differences.

— upside and downside
— dynamic and static
— glad and sad
— fresh and moldy
— day and night

←
Love Sick
Keetra Dean Dixon

Long(er) Form Lettering

↑
Yeji Yun

Surely a picture is worth a thousand words, but so, too, can letters paint a picture!

The exercises in this book are meant to be flexible and scalable—they might apply to just a single letter or an entire line of text.

→ For this exercise, think narratively. Do you have a story to tell? How can you tell that story through a series of lettered statements? Think of this exercise almost like a comic book: a story told over discrete instances, frames, or moments.

Visualizing Voice

Still wondering what to letter? Let's talk about it.

> Hey girl, what's up?

> Oooh, not much, im just tackling **laundry mountain**! Putting some clothes in bags for donation. Hbu?

→ Begin this exercise by reaching out to a friend, a family member, a classmate, or an online acquaintance. You'll want to record the conversation or have a pen and paper handy. Over the course of the conversation, try to

> Laundry mountain, the fiercest of summits. I'm just **lying on the couch**, wondering what to do next. Should I make lentil soup or some kind of pasta for dinner?

> Oh yeAh. Im definitely thinking about dinner. On **tonight's menu**—black lentil dal with brown rice, quinoa, and shredded greens.

isolate a few meaningful, funny, or curious words spoken by your partner. Use one or more of these words or sentences in your next piece of lettering!

> **Ooooh, yum**, OK, maybe I'll make lentils, too.

How about we make this a two-way game? If your conversational partner is in on it and wants to letter, too, allow them to pluck out a few words you've spoken. Try assigning a style of lettering to you and your partner.

How might you combine your lettering into a collaborative work?

Letter as Diagram

Have you ever found yourself in a position where you need to convey layers of information and a paragraph of text just won't do? Enter, the diagram.

Diagrams, charts, and data visualizations help us to process complex information in a visual and sometimes pictorial way. The rise in food consumption over time might be better understood when visualized linearly on a chart rather than read in a sentence like this one. Pie charts show proportions of a whole. Timelines represent moments in a span of time. Venn diagrams show relationships and commonalities among separate entities.

Data used in diagrams can be divided into two different types: quantitative data and qualitative data. Quantitative data is number based, whereas qualitative data is narrative based.

→ First, gather your data. Is it percentages of people who eat grilled cheese on the East Coast? Is it layers of vegetation in the rainforest? Once you have your data set, determine what kind of visualization is most appropriate. Are you comparing and contrasting two things? Maybe a Venn diagram would work best. Are you tracking the movement of animals over terrain? Maybe a map would work well.

Next, assess what style of lettering feels appropriate. If you're comparing the ratio of peanut butter to jelly in the average person's sandwich, maybe you create letters that are wiggly and goopy. In contrast, maybe you're depicting Brutalist architecture in Europe. Perhaps rigid and solid letterforms might work best.

Is your data quantitative? Get creative with numerals. Qualitative? How can you use lettering and language to visualize the information you've gathered?

How many quarts are in a gallon?

Aha!

On the Writings of the Insane contains images of drawings by asylum patients in England in the late 1800s. These lettered diagrams may be difficult to decode, but they have a complex and layered beauty that captivates the eye.

←

Illustration from G. Mackenzie Bacon, *On the Writings of the Insane*, artist unknown, 1870

Renga

Good things come to those who collaborate.

Renga, meaning "linked poem," is a form of collaborative poetry that originated in Japan more than seven hundred years ago. Poets would work in pairs or in small groups, taking turns writing lines of poetry. Often, the poets would take turns writing two- and three-line stanzas. In this back-and-forth process, the poets would develop a theme that would unite the poem, often centered around pastoral landscapes, seasons, and daily happenings. These poems could be hundreds of lines long!

with

→ Starting with a blank page can be intimidating, but, with the help of a friend, that anxiety can be eased. In this exercise, you'll create a piece of lettering and then pass it off to a friend. Then, à la ping-pong, your collaborator will pass it back to you, and so on. Stop whenever it makes sense. Feel free to choose your own increments: letter by letter, word by word, stanza by stanza.

"When we build, we take bits of others' work and fuse them to our own choices to see if alchemy occurs."

Frank Chimero,
The Shape of Design

Don't forget to choose a theme! It will help you stay focused and encourage a shared understanding.

Friends

Rebuses and Grammagrams

A rebus is a visual puzzle that uses a combination of letters and images to communicate a message.

You may have encountered these picture puzzles in children's books. For good reason! Rebuses help children to correlate and comprehend not just words and images, but also the way words sound. But don't be fooled—rebuses aren't just for kids! They can get quite challenging, requiring multiple images and the addition and subtraction of letters and sounds.

→ Start with an idiom such as "it's raining cats and dogs" or "hit the hay" or "break a leg." Next, determine which words you can illustrate as images and which you can letter. Hierarchy and word order will be important, as they will give the reader clues to the solution.

Alternatively, try making a game of this exercise with a friend. Using simple compound words—such as *butterfly* or *catfish* or *eyeball*—sketch out quick lettered compositions to stump your opponent!

PICTORIAL PROVERBS.

The proof of the pudding is in the eating.

Children and chicken must always be picking.

←
Guess Me: A Curious Collection of Enigmas, Charades, Acting Charades, Double Acrostics, Conundrums, Verbal Puzzles, Hieroglyphics, Anagrams, Etc., Frederick D'Arros Planché, 1879

A grammagram is a rebus made solely of letters and numbers. If you send text messages, you've probably used a grammagram.

While rebuses traditionally take the form of riddles and idioms, the grammagrams we know today are used as shorthand slang. CUL8R. FX. QT. Y?

→ Do you know of any words or expressions that could be transformed into a grammagram? Break down each word into syllables. Could any of these syllables be swapped for a single letter or even a numeral? Next time you send your friend a grammagram text message, send them a photo of your lettering instead!

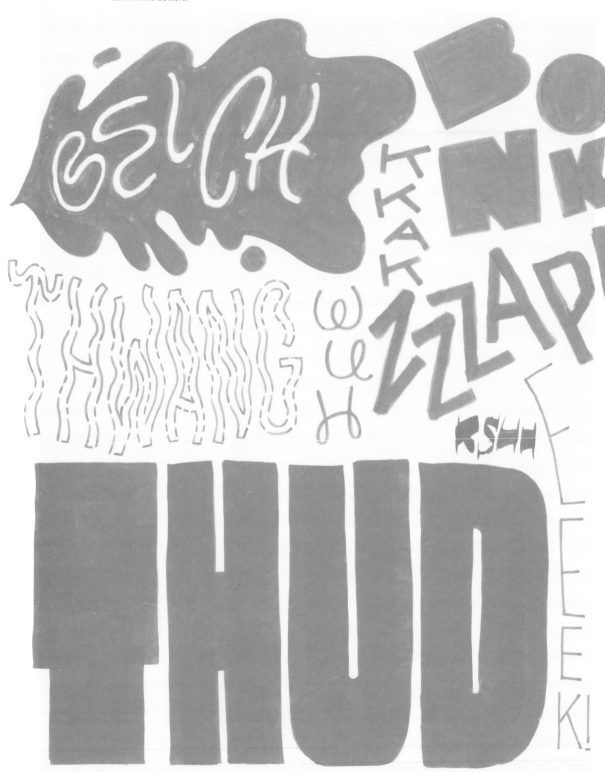

Onomatopoeia

"Ru-h ru-h-h-h-h-h, Poeoeoe, Tik-tik-tik-tik. Pre. R-r-r-r-r-uh-h. **Huh! Pang. Su-su-su-su-ur. Boe-a-ah. R-r-r-r.** Foeh... **a multiplicity of sounds, interpenetrating.**

Automobiles, buses, carts, cabs, people, lampposts, trees...all mixed; against cafes, shops, offices, posters, display windows: a multiplicity of things. Movement and standstill: diverse motions. Movement in space and movement in time. Manifold images and manifold thoughts."

So goes the first paragraph of the Dutch painter Piet Mondrian's essay "Les Grandes Boulevards." In it, he celebrates the cacophony of urban spaces, the rhythm and movement of people and vehicles. He celebrates the people he sees and assesses their motivations and desires. To bring our imaginations closer to his observations, he starts the essay with onomatopoeia—the nonsensical formation of a word as an interpretation of sound.

Onomatopoeia is one of the earliest forms of vocalization that we learn as children. What sound does a sheep make? Baa baa! What sound does a rooster make? Cock-a-doodle-do!

Even though these words sound silly, they are culturally shared by those who speak the same language. That also means that different interpretations of sounds vary based on what language you speak. In Spanish, the sound of a rooster is spoken as *kikiriki*.

Onomatopoeia can immediately convey sound, and as we've seen in this book, the way in which letters are drawn can exude a certain tone. Combined, a lettered onomatopoeia can be a powerful force!

Listen in—whether to animal noises or human interjections or the sounds in your neighborhood—and letter what you hear.

LET! US! LETTER!

Many of the exercises in this section of the book play with typography as voice: as perspective, to represent an individual, an attitude, or an idea. From plays on words to representations of conversation, we've discussed how typography can add visual emphasis to a message. Lettering is perhaps at its most provocative when deployed in the protest poster.

"Typography images those who are speaking."

Marlene McCarty,
activist and designer

Protest posters demand attention. They demand action. They serve a cause. They visualize the voice of the person who is holding it.

In an age when almost everyone has access to a computer and digital typesetting tools, very few people actually lean on these tools to make their posters. In fact, protest posters are often made from cheap, accessible materials: posterboard, cardboard, fabric, paint. These open-source materials often support the protester's message. Why are digital methods so often ignored? To designer and activist Marlene McCarty, handmade letters express a resistance to institutional voice: "No one wants their voice to be framed in the visual language of big business, mega corporations, banks, or commerce."

→ What do you stand for? Is there a cause about which you feel particularly passionate? Find whatever materials you can get your hands on and make a poster about it. Keep it concise and use direct language; typically two to four words is a good range. Perhaps you can make use of the rebus technique from the previous exercise to introduce imagery, icons, or type-as-image into your poster.

Remember, there's no cause too big or too small: "Normalize pizza for breakfast!"

Last but Not Least: Punctuation

The backbone of language! Punctuation helps us sort our thoughts and gives tone, inflection, and context to our sentences. Punctuation aids us in understanding a text's true message. It marks the difference between "Let's eat, Grandma!" and "Let's eat Grandma!"

A period adds clarity and finality to a sentence. A question mark— even without words before it—can signal curiosity or confusion. An exclamation point can add emphasis, excitement, or even danger.

→ For this, the final exercise, letter a word or a short phrase. You can even use lettering that you've made for previous exercises in this book. Now, attach punctuation. How does changing punctuation change your lettering's intent? If ever you create lettering for a client or for public consumption, adding punctuation can provoke a reaction from your audience.

So, go forth. Shout out loud. Give pause. Ask a question.

THE END.

THE END!

THE END?

THE END.

Image Credits

006 Photo by Claudio Schwarz
 Unsplash.com

 Photo by Jon Tyson
 Unsplash.com

007 (left) Photo by Mayank Baranwal
 Unsplash.com

 (center) Photo by Amaury
 Gutierrez, Unsplash.com

010 Photo by Wilhelm Gunkel
 Unsplash.com

 Photo by Karen Penroz
 Unsplash.com

011 Photo by Michael Walker
 Unsplash.com

013 https://archive.org/details/
 newspenceriancom00auth

014 Woodblock from author's
 personal collection

 https://archive.org/details/
 palmermethodbus00palm

015 https://archive.org/details/
 cu31924029485467/page/n11/
 mode/2up

016 In illustration: https://
 archive.org/details/
 palmermethodbus00palm

017 James Edmondson

029 James Edmondson

036 Kelsey Elder

037 Kelsey Elder

041 530 TypeClub

042– Lakwena
043

045 Félicité Landrivon

050 Max McCready

051 Carter Pryor

054 Carter Pryor

056 Jocelyn Yun

058– Vanna Vu
059

060 Zrinka Buljubašić

061 Marian Bantjes

062 Anna Sing
 Ola Niepsuj
 Ian Lynam

063 Julia Rumburger
 Onanma Okeke
 Marco Cheatham

064 James Edmondson

066 Bráulio Amado

067 Happening Studio

068– Nolen Strals
069

074 Annik Troxler

075 Vanna Vu

076 Zofia Kaljs
 Cheryl D. Holmes Miller

078– Zrinka Buljubašić
079

080 James Edmondson
 Cheryl D. Holmes Miller

081 https://publicdomainreview.
 org/collection/sylvestre-
 alphabet-album

082 https://publicdomainreview.org/
 collection/the-model-book-of-
 calligraphy-1561-1596

084 Pavel Ripley

088– Cheryl D. Holmes Miller
089

090 Cryptogram Ink
 Annik Troxler

092– Kelsey Elder
093 Kelsey Dusenka,
 and Johannah Herr

094 Shannon Levin

095 Cyrus Highsmith

099 Paula Scher

100 Dingding Hu
 Zofia Klajs

102 Tré Seals

103 https://publicdomainreview.
 org/collection/aratea-making-
 pictures-with-words-in-the-
 9th-century#0-1

104 Cyrus Highsmith

106 https://commons.wikimedia.
 org/wiki/File:Muybridge_horse_
 gallop.jpg

107 Mundoba

108– Kelli Anderson
109

111 Shannon Levin
 Cheryl D. Holmes Miller

112 https://publicdomainreview.
 org/collection/jan-van-kessel-
 s-signature-of-caterpillars-and-
 snakes-1657

116– Laura Gonima
117

119 Ed Fella

121 Emily Eisenhart

Acknowledgments

First, I owe an enormous thank-you to Ellen Lupton. From answering each of my emails in record time to offering me sage wisdom when I needed it most, you propelled both me and this book forward. I'll never forget your advice on publishing: enjoy the process. Wise words for design, writing, and life.

Big thanks to Jesse Ragan and Ben Kiel of XYZ Type for the generous use of their typeface Escalator.

Thanks to you, Ken Barber. Your jaw-dropping mastery of lettering awoke a curiosity within me. You are a great and generous teacher. You are energetic but not in that annoying way. Without you, I wouldn't be able to share the Unger Method with the readers in this book—it still gets me every time.

Tremendous thanks to my editors, Jennifer Thompson and Sara Stemen. Jennifer: Thank you for taking a chance on me. Your kindness and warmth were felt through the screen in our many video chats. To Sara: were it not for your careful eye, this book would have many, many, many unnecessary hyphens.

I'm indebted to you, Ian Lynam, for your just-do-it attitude and relentless encouragement when this book was in its infancy. Big hugs, my dude! Thanks also to Carma Gorman. Your knowledge of the publishing world helped guide me through the process.

Paige, Lindsay, Jim, Jason: you have my deepest gratitude for your unending patience, for listening to me complain, doubt, and question nearly every page of this book. Your support, encouragement, and enthusiasm kept me going during a truly unique time to be writing a book.

Mom, Dad, and Blake: without your lifelong support of my interests, creative endeavors, and education, this book simply would not have been possible.

And without you, Kyle, life wouldn't be very much fun (and page 55 wouldn't have such a spectacular foot model). I love you lots.

Notes

iii Gerard Unger, "Prologue" *Theory of Type Design* (Rotterdam: nai010, 2018), 11.

ix Gerard Unger, "Typography," *Theory of Type Design*, 145.

6 Johanna Drucker, *The Alphabetic Labyrinth: The Letters in History and Imagination* (London: Thames and Hudson, 1995), 11.
 "Hand-Lettering, Calligraphy, Typography: What's the Difference?," Hand-Lettering for Beginners, accessed March 5, 2021, https://www.handletteringforbeginners.com/blog/lettering-calligraphy-typography.

7 Sofie Beier, "The Legibility of Letters and Words," ATypi 2016, https://www.atypi.org/type-typography/the-legibility-of-letters-and-words.
 "What *Is* Calligraphy," Calligraphy Skills, accessed February 18, 2021, https://www.calligraphy-skills.com/what-is-calligraphy.html.

10 Matt Kahn, "Design/Soul and Body: Propaganda," Lecture 3 (presentation, Stanford, CA, 2005).

12 Austin Palmer, *The Palmer Method of Business Writing* (New York: A. N. Palmer Co., 1935), 1.

20 Tobias Frere-Jones, "Typeface Mechanics: 001," Frere-Jones Type, February 10, 2015, https://frerejones.com/blog/typeface-mechanics-001/.

28 Hannes Famira, "The Complex Task of the Serif," *Hannes Famira* (blog), March 2015, http://famira.com/article/serifs.

32 Nick Douglas, "An Artist Explains What 'Great Artists Steal' Really Means," Lifehacker, September 27, 2017, https://www.lifehacker.com.au/2017/09/an-artist-explains-what-great-artists-steal-really-means/.

44 Yi-Chuan Chen, Pi-Chun Huang, Andy Woods, and Charles Spence, "When 'Bouba' Equals 'Kiki': Cultural Commonalities and Cultural Differences in Sound-Shape Correspondences," *Science Reports* 6, no. 26681 (2016), https://doi.org/10.1038/srep26681.

47 Andrew Russeth, "Here Are the Instructions for Sol LeWitt's 1971 Wall Drawing for the School of the MFA Boston." *Observer*, October 1, 2012, https://observer.com/2012/10/here-are-the-instructions-for-sol-lewitts-1971-wall-drawing-for-the-school-of-the-mfa-boston/.

52 Toshi Omagari, *Arcade Game Typography* (London: Thames and Hudson, 2019), 11.

81 Eric Gill, *An Essay on Typography* (London: Sheed and Ward, 1931), 47.
 Marta Bernstein, "Ugly Typefaces with Marta Bernstein," Vimeo, 25:05, Typographics NYC, 2019, https://vimeo.com/359606800.

84 "The Story of Ravel's *Boléro*," Classic FM, accessed February 18, 2021, https://www.classicfm.com/composers/ravel/guides/story-maurice-ravels-bolero/.

85 Bruce Willen and Nolen Strals, *Lettering and Type: Creating Letters and Designing Typefaces* (New York: Princeton Architectural Press, 2009), 27.

87 William Cowper, "The Task, Book II, The Timepiece," *The Task and Other Poems* (London: Cassell & Co., 1899), https://www.gutenberg.org/files/3698/3698-h/3698-h.htm.

89 Cheryl D. Holmes Miller, email message to author, July 30, 2020.

103 "Aratea: Making Pictures with Words in the 9th Century," The Public Domain Review, https://publicdomainreview.org/collection/aratea-making-pictures-with-words-in-the-9th-century.

106 Scott McCloud, *Understanding Comics* (New York: HarperCollins, 1994), 110.

110 "Design Kit: The Human-Centered Design Toolkit," Ideo, accessed February 18, 2021, https://www.ideo.com/post/design-kit.

119 Ed Fella, email messages to author, August 6, 2020.

122 Chloe Wooldrage, "Found Font (1995–present)," *Medium* (blog), October 2017, https://medium.com/fgd1-the-archive/found-font-1995-present-2328b96459fe.

125 Rob Walker, *The Art of Noticing* (New York: Alfred A. Knopf, 2019).

137 Gerrit Noordzij, *The Stroke: Theory of Writing* (London: Hyphen, 2005), 13.

160 Robert Brownjohn and Ivan Chermayeff, *Watching Words Move* (New York: self-pub., 1958), http://robertbrownjohn.com/featured-work/watching-words-move-4/.

163 Ian Lynam, "Doof Doof," Ian Lynam Design, http://ianlynam.com/work/doof-doof/.

170 Frank Chimero, *The Shape of Design* (self-pub., 2013), 38.

175 Piet Mondrian, *The New Art—The New Life: The Collected Writings of Piet Mondrian,* ed. Harry Holtzman and Martin S. James (Boston: G. K. Hall, 1966).

176 Marlene McCarty, "Resist Typography" Vimeo, 23:37, Typographics NYC, 2017, https://2017.typographics.com/schedule/marlene-mccarty/.

"Kelcey Gray loves letters. Her bright, funny, and forgiving book is filled with ingenious illustrations, geeky technical info, and playful exercises. It's a perfect introduction for newcomers and a deeply delicious dive for folks who work with type but have never really touched it with their own two hands. Relax, get personal, and be yourself. The alphabet can't wait to meet you!"

— ELLEN LUPTON, author of *Thinking with Type*

Learn to create unique lettering— from the quirky and lively to the sophisticated and polished.

The imaginative projects in *Let's Make Letters!* will improve your lettering abilities step-by-step. Accessible explorations of typography basics and traditional calligraphy methods build up to forays into the expressive and experimental—with prompts and tips that go beyond the margins. Take risks! Have fun! Make letters!

KELCEY GRAY is a graphic designer who works with words to explore the possibilities of typography and lettering. She teaches design and typography at the University of Texas at Austin, and her work can be found at kelceygray.com and on Instagram at @kelcey_gray.

Princeton Architectural Press
www.papress.com

US $24.95 / UK £17.99
ISBN 978-1-64896-047-5

52495

9 781648 960475